DISCOVER DRAWING SERIES

Draw Sports Figures!

Lee Hammond

NORTH LIGHT BOOKS

Cincinnati, Ohio

ABOUT THE AUTHOR

Polly "Lee" Hammond is an illustrator and art instructor from the Kansas City area. Although she has lived all over the country, and was raised in Lincoln, Nebraska, she calls Kansas City home.

She is now the owner of a new teaching studio, the Midwest School of Illustration and Fine Art. There she teaches "artists" of all ages, covering a variety of art techniques and mediums, with the focus on portraits and realism. The studio is located in Lenexa, Kansas, a suburb of Kansas City.

Lee has been an author for North Light Books since 1993. She is also a traveling seminar instructor, demonstrating and teaching various art techniques, including use of the Prismacolor line of art products.

She has three children, Shelly, LeAnne and Christopher, and one granddaughter, Taylor. They all reside together in Overland Park, Kansas.

Draw Sports Figures! Copyright © 1999 by Lee Hammond. Manufactured in the United States of America. All rights reserved. No part of this book may be reproduced in any form or by any electronic or mechanical means including information storage and retrieval systems without permission in writing from the publisher, except by a reviewer, who may quote brief passages in a review. Published by North Light Books, an imprint of F&W Publications, Inc., 1507 Dana Avenue, Cincinnati, Ohio 45207. (800) 289-0963. First edition.

Other fine North Light Books are available from your local bookstore, art supply store or direct from the publisher.

03 02 01 00 99 5 4 3 2 1

Library of Congress Cataloging-in-Publication Data

Hammond, Lee.
 Draw sports figures! / by Lee Hammond.—1st ed.
 p. cm.—(Discover drawing series)
 Includes index.
 ISBN 0-89134-895-6 (alk. paper)
 1. Action in art. 2. Athletes in art. 3. Drawing—Technique.
 I. Title. II. Series.
NC785-H36 1998
734.4—dc21 98-20235
 CIP

Edited by Glenn L. Marcum
Production edited by Bob Beckstead
Designed by Mary Barnes Clark

DEDICATION

This book is dedicated to my son, Christopher Dale Hammond, who forever in my eyes and heart will be my favorite "All Star."

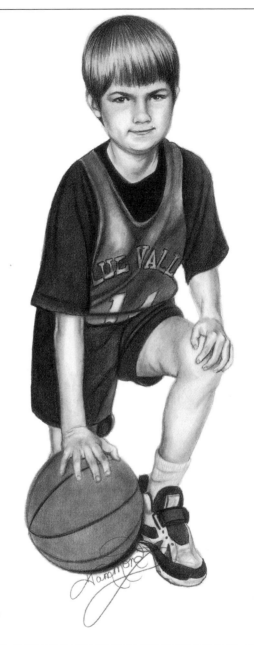

Christopher Hammond
My #1 All Star

ACKNOWLEDGMENTS

This has been an exciting career year for me. So many changes have taken place, along with many wonderful opportunities. But what has remained constant, is the unwavering friendship and support I have received from my students. Whether they are my "regulars" who frequent my studio on a weekly basis, or students and teachers that attend my traveling seminars, or the many readers who contact me through my publisher, one thing is always the same: The encouragement I receive from them is simply overwhelming.

To all of you who have gone from "I could never do that!" to "I can't believe I am doing this," I want to thank you from the bottom of my heart. I hope I will continue to be a source of artistic inspiration and instruction for many years to come. Having said all that, acknowledgment and gratitude must be directed to the wonderful people at North Light Books, particularly my production editor, Bob Beckstead and my new editor, Glenn Marcum, who continue to allow me this opportunity. Without you, well . . . never mind!

CONTENTS

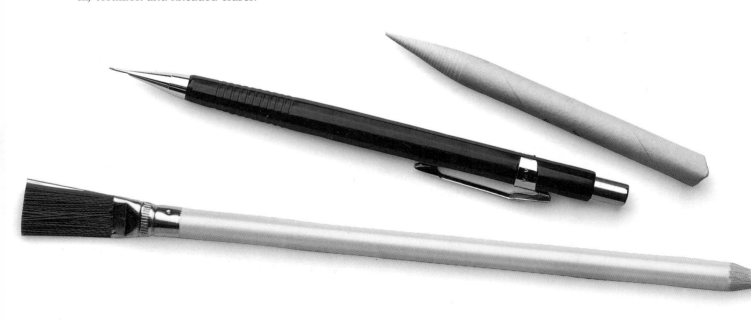

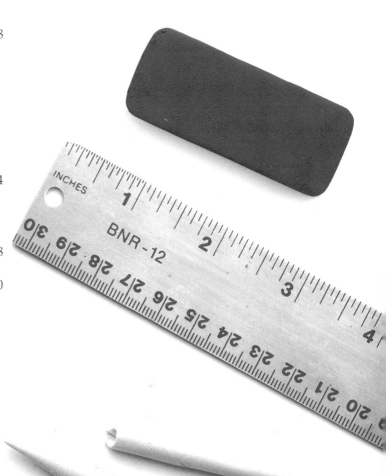

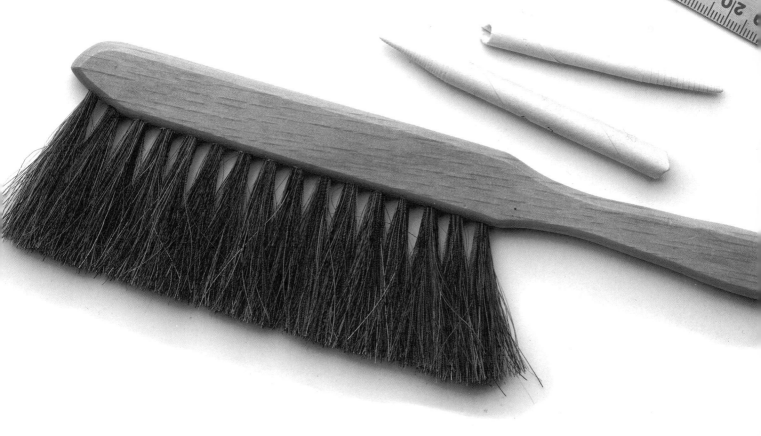

Extreme overlap creates strong contrasts of light and dark.

Fabric stresses

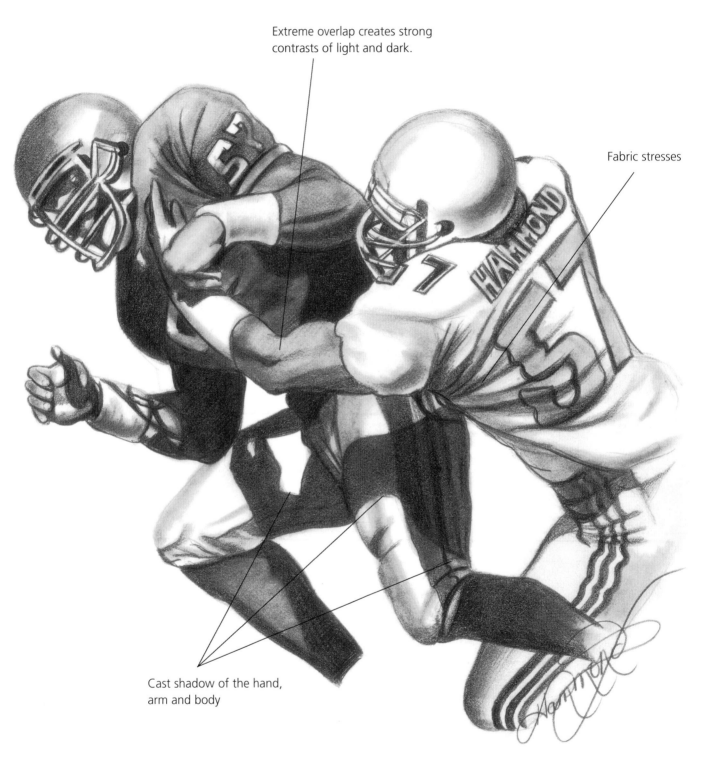

Cast shadow of the hand, arm and body

Watch for the cast shadows created by the overlap of these figures (take note of the shape of the hand). Watch for the stresses and folds in the uniform and how it affects the number on the player's back.

YOU CAN DO IT!

Some of the most powerful drawings ever rendered have been sports illustrations. The combination of lighting, shapes and movement can only be seen in the action-packed situations found in sports.

While looking at the illustrations in this book, pay close attention to the details. Especially watch for the lighting effects. Since many sports are played outside, sunlight plays an important part in the way things look. It can make the lighting seem quite intense with the shadows equally extreme. Shining down on the figures this lighting creates wonderful contrasts.

Look for the movement created by the action. Watch for areas of overlap, where legs or arms cast shadows on underlying surfaces. Notice where bodies touch or cross over one another.

Also study the clothing and uniforms. All of this action creates untold effects on the fabric, causing folds, stresses and pulls. It also creates distortion and interruption of any patterns, stripes, names and numbers.

Speaking of names and numbers, you will notice that every player in this book is "Hammond, #57." This is to protect and not infringe on any professional athlete or sports organization. To draw these people for publishing or profit you must always get signed permission and releases from them. Any likenesses or resemblance to any known athlete in these illustrations is coincidental.

BEFORE AND AFTER

I find it interesting, as a teacher, to see the progress my students make. These are two examples of what can happen given the right information and a little practice.

Remember, not everyone draws the same and everyone learns and sees things differently. Some pick up on the techniques very quickly, while others may need more time. No matter which category you may belong to, one thing is essential: practice! The more you work at your drawing, the better you will be. Good luck!

Too much outlining

Because of the out-of-the-ordinary position of the body, the proportion of this figure was hard for my student to capture. In particular, this can be seen in the shape of the head, face and arm.

Distortion and innacuracy of proportions

Shading replaces outlining to create edges.

Better proportions

Note: Sometimes in an unusual pose, such as the gymnast, it may help you to turn your paper to see the subject in a more familiar perspective. This face was easier to draw when the reference and drawing paper were turned sideways. It then appeared as more of a profile view.

After some explanation of the size relationships between shapes (for instance, the length of the extended leg is the same distance as the measurement to the hand), this drawing appears much more accurate. I also had the student use shading instead of outlining for greater realism.

Artwork by Lanny Arnett

A young student of mine wanted to draw himself from some of his own baseball snapshots. Although his first attempt shows obvious drawing talent, it is lacking a few of my techniques.

Let's look at some of the areas in need of refinement. These are the things which separate the work of a novice from that of an experienced artist.

1. The shapes in this first drawing are good representations but not accurate. Although the uniform and head gear are nicely depicted, the human form is distorted. The neck is too thick and the shoulders are too narrow.

2. Although the student did attempt some shading, the overuse of outlining makes it seem cartoonlike. What shading there is, is loose and irregular.

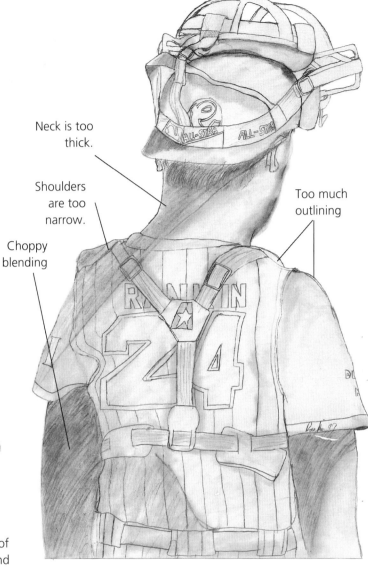

Neck is too thick.

Shoulders are too narrow.

Choppy blending

Too much outlining

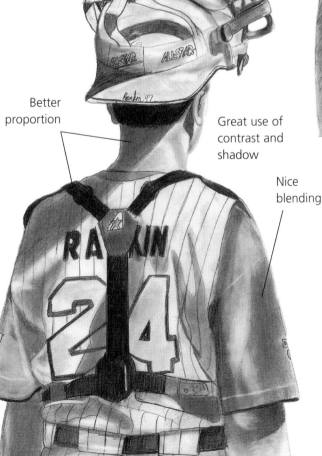

Better proportion

Great use of contrast and shadow

Nice blending

Now let's study the second drawing. Look how polished it looks in comparison. The anatomy is much more accurate. Look at the size relationship of the head, neck and shoulders.

Notice how there are no more hard outlines. Instead, shading has been added to create edges, lending a more realistic impression. The rich contrasts of light against dark give the viewer a strong sense of sunlight. See how the bill of the hat casts an intense shadow down on the neck of the player.

The shading has been blended much more smoothly than in the first drawing. This is, overall, a very good drawing.

Artist: Paul Rankin

MATERIALS

You cannot do quality artwork with inadequate art materials. My blended pencil technique requires the right tools to create the look. Do not scrimp in this department or your artwork will suffer. I have seen many of my students blame themselves for being untalented when it was their supplies keeping them from doing a good job. The following list will help you be a better artist.

Smooth Bristol Boards or Sheets—Two-Ply or Heavier

This paper is very smooth (plate finish) and can withstand the rubbing associated with the technique I'll be showing you.

5mm Mechanical Pencil With 2B Lead

The brand of pencil you buy is not important; however, they all come with HB lead—you'll need to replace it with a 2B lead.

Blending Tortillions

These are spiral-wound cones of paper. They are not the same as the harder, pencil-shaped stumps that are pointed at both ends. These are better suited for the blended pencil technique. Buy both large and small.

Kneaded Eraser

These erasers resemble modeling clay and are essential to this type of drawing. They gently "lift" highlights without ruining the surface of the paper.

Typewriter Eraser With a Brush on the End

These pencil-type erasers are handy due to the pointed tip, which can be sharpened. They are good for cleaning up edges and erasing stubborn marks, but their abrasive nature can rough up your paper.

A 5mm mechnaical pencil and blending tortillions.

Horsehair Drafting Brush

These wonderful brushes will keep you from ruining your work by brushing away erasings with your hand and smearing your pencil work. They will also keep you from spitting on your work by blowing the erasings away.

Pink Pearl or Vinyl Eraser

These erasers are meant for erasing large areas and lines. They are soft and nonabrasive and will not damage your paper.

Workable Spray Fixative

This is used to seal and protect you finished artwork. It's also used to "fix" an area of your drawing so it can be darkened by building up layers of tone. "Workable" means you can still draw on an area after it has been sprayed.

Drawing Board

It's important to tilt your work toward you as you draw to prevent distortion that occurs when working flat. A board with a clip to secure your paper and reference photo will work best.

Ruler

This is used for graphing and measuring.

Acetate Report Covers

These are used for making graphed overlays to place over your photo references. They help you grid what you are drawing for accuracy.

Magazines

These are a valuable source of practice material. Collect magazine pictures and categorize them into files for quick reference.

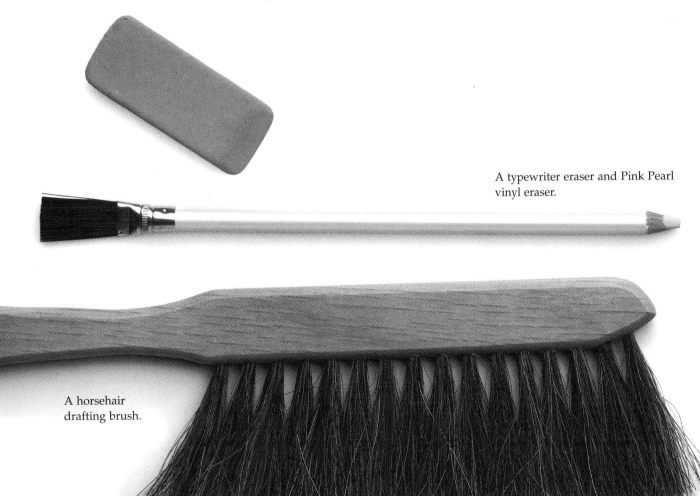

A typewriter eraser and Pink Pearl vinyl eraser.

A horsehair drafting brush.

BASIC SHAPES

Everything we see is made up of interlocking shapes. It is important to see these shapes in order to draw anything accurately. The following are some of the most commonly used basic shapes.

The Cylinder

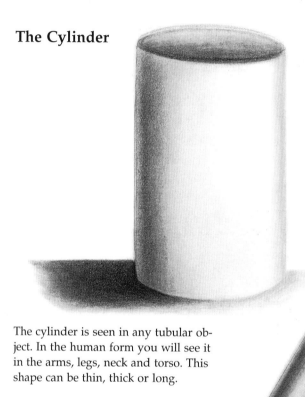

The cylinder is seen in any tubular object. In the human form you will see it in the arms, legs, neck and torso. This shape can be thin, thick or long.

The Sphere

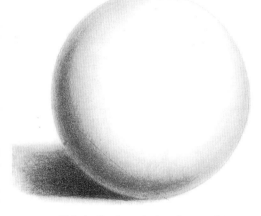

This is the foundation for anything with a rounded shape.

The Egg

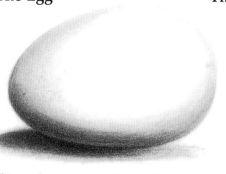

This can be seen in the shape of the human head (not to mention a football).

The Cone

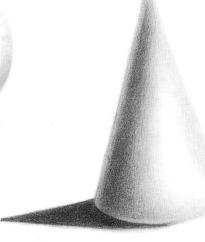

Although this shape is less common in the human form, it can be seen in clothing. For an example, turn to the second drawing of the baseball player on page 9. If you look closely at the sleeve on the right you will see the cone shape.

BODY SHAPES

To successfully draw sports figures using my blended pencil technique, there are two important elements that must be mastered. The first one is *shape* and the other is *blending*.

Let's look at some of the basic shapes seen in the human form. I am not talking about the shapes of the inner stucture, like the skeleton and muscles, but the simple, basic shapes that everything is made up of.

This grouping may seem like a strange collection of shapes, but you will see how they all fit together to represent the shape of the body.

These shapes are modified versions of those on the opposite page. Viewed like this you can see how they resemble the shapes of the body. Take note of how the shading on these shapes makes them seem three-dimensional.

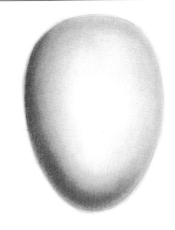

This oval, or egg, shape can be seen in the shape of the human head.

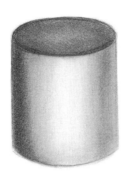

This short cylinder can be seen in the shape of the neck and waist.

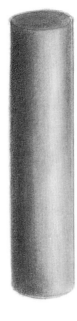

The long cylinder, or tube, can be seen in the arms and legs.

A rounded-off triangle can be seen in the shape of the upper body or chest area.

By turning this shape upside down, you now have the shape of the lower body or hip area, although this area is smaller than the upper body.

THE EIGHT-HEAD SCALE

When put together to create the body, these shapes must be drawn in proper proportion. This figure scale shows how much size should be given to each shape.

Review and memorize these measurements so your drawings will be accurate.

This is called a *head scale*. It divides the figure into equal increments all the size of the head. Most adults are between seven and eight heads tall. For more detailed information on drawing the entire figure, refer to my book, *Draw Family & Friends!* (North Light Books, 1997).

Pay particular attention to where the arms fall against the body. A common mistake is drawing the arms too short. Always remember the elbows are at the waist and the fingertips touch mid-thigh.

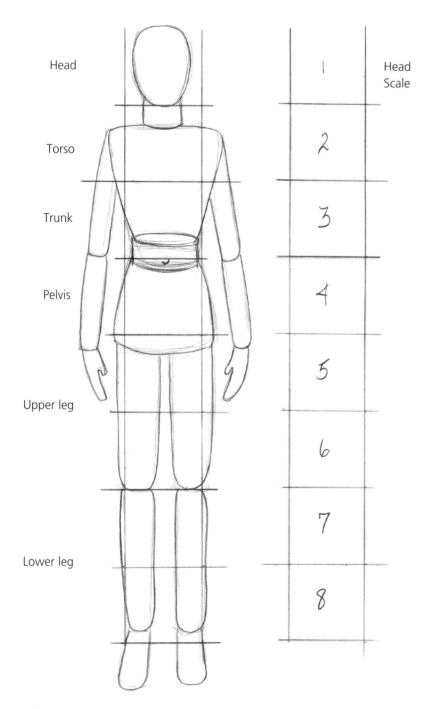

The head scale divides the human body into equal measurements, each the size of the head. Most adults are between seven and eight heads tall.

Be sure to memorize how the body is divided and how each body part relates in size to the others.

1. The head size is the comparison for each section of the body.

2. The second "head" measurement takes you down to the chest, dividing the chest and upper arm.

3. The third measurement takes you to the stomach region or trunk. This line will fall around the navel and cut across the arm at the elbow.

4. The fourth measurement takes you to the lower pelvic region where the legs meet the body. It also lines up with the wrist area of the arm.

5. The fifth measurement falls in the middle of the upper leg just below the thigh. Notice how the fingertips almost reach this point.

6. The sixth head measurement takes you down to the knees.

7. The seventh measurement falls along the shins.

8. The last measurement takes you to just below the ankle where the foot hits the floor.

SKELETAL STRUCTURE

The skeletal system is the foundation, or framework, for the shape of the human body. While drawing the figure, remember the shape of the bones and muscles underneath. I prefer to teach my students observation as opposed to anatomy. If you closely study what you are drawing and try to draw exactly what you are seeing, then the understanding of the body part is much clearer. So, rather than devote an entire chapter to the bones and muscles, I will try to make you see things, instead, as shapes. If a shape seems confusing and you are not sure what is causing a particular area to look the way it does, then refer to the anatomy in these illustrations for clarification.

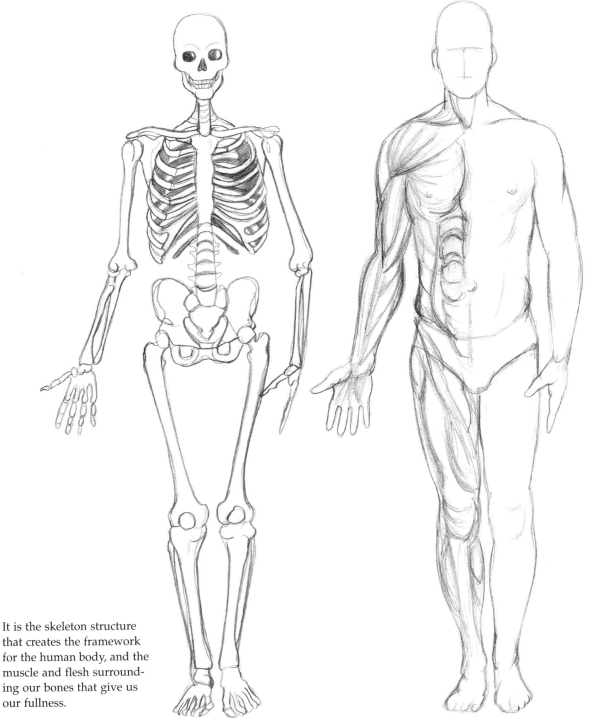

It is the skeleton structure that creates the framework for the human body, and the muscle and flesh surrounding our bones that give us our fullness.

BODY TYPES

There are many differences between the male and female body. The male body is usually larger with a thicker, bulkier appearance. It is generally more angular and boxy.

 The female body, on the other hand, is usually more curved and tapered. Even if the female is quite muscular, the form will still appear more slender than a male.

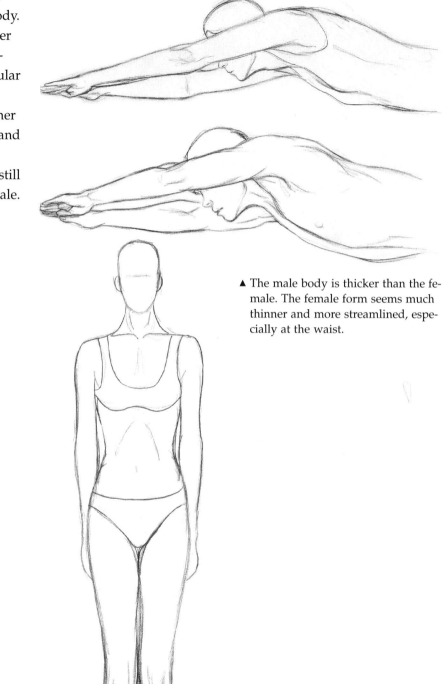

▲ The male body is thicker than the female. The female form seems much thinner and more streamlined, especially at the waist.

The male figure is more angular and boxy.

The female figure is more slender and has a tapered appearance. Even a muscular female will be more curved than a male.

THE MUSCLE CHALLENGE

In sports figures the muscles are more developed than they are in average bodies. This leads to a challenge for the artist trying to draw them. This illustration shows the developed muscle structure in both a blended, rendered form and the blocked-in sketched appearance.

Can you see how important it is to create the roundness of the individual muscles with your shading? It is the gradual blending of the dark tones into the light areas that creates the dimensional quality. For more on blending and shading, see chapter four.

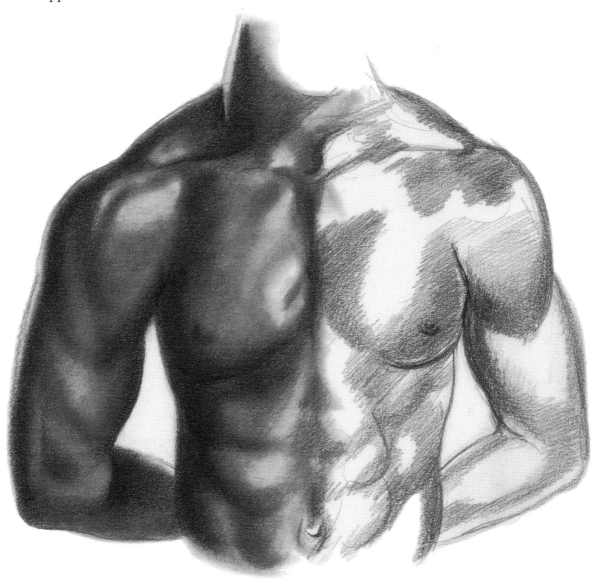

This shows the muscle structure of the upper body. Although the right side shows the shape and form, the blended side looks more realistic. This is the difference between a sketch and a rendering.

MUSCLES AS SHAPES

As I said before, the muscle structure in a sports figure can be quite pronounced. Always look for the basic shapes that make up the overall structure.

For your drawings to appear three-dimensional, you must create the illusion of depth and form. By seeing into the object to the underlying basic shape you will be better able to achieve this dimensional quality.

Can you see how these arms and legs have been broken down into three-dimensional shapes? The cylinder is clearly evident in each one of them.

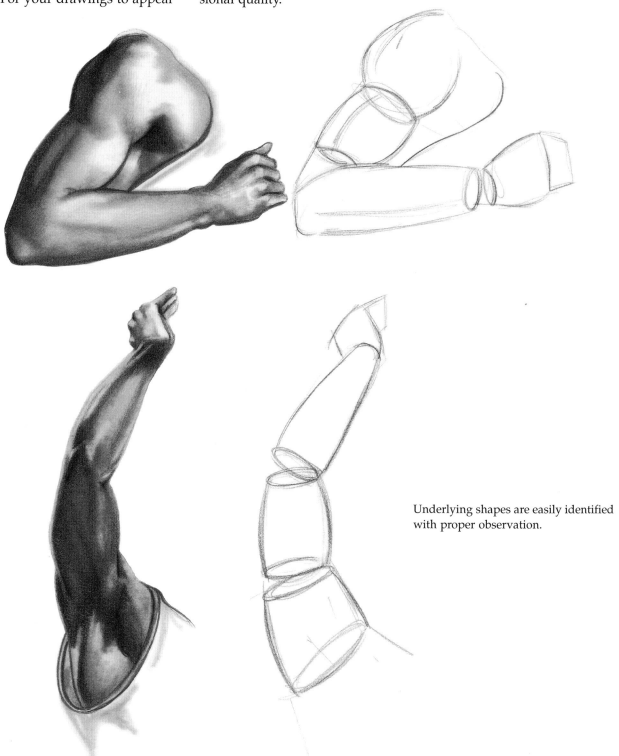

Underlying shapes are easily identified with proper observation.

Cylinders

When seen as basic shapes, all of these drawings can be seen as cylinders. This is what gives them their dimensional quality. It is the blending and shading that make the drawings appear realistic.

Angles

Angles are also important. Look at how this muscular arm has been broken down into geometric, angular shapes. Seeing it in this way prevents you from making things too rounded. This way shows you all the variances in each muscle shape.

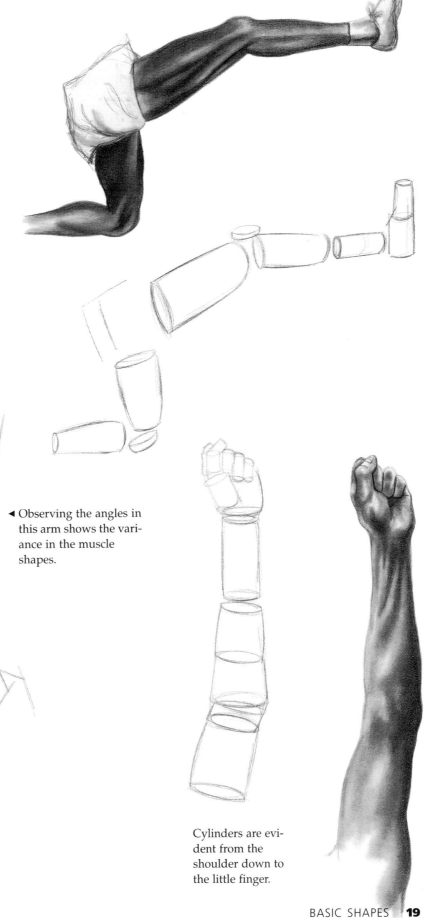

◄ Observing the angles in this arm shows the variance in the muscle shapes.

Cylinders are evident from the shoulder down to the little finger.

BLENDING AND SHADING

A smooth blend from dark to light is the key element in my drawing style. While blending may look simple, especially with these beginning exercises, it requires a lot of practice to make it appear smooth and gradual.

This is where I start all of my students. This is where you will become familiar not only with the technique but also with your tools. It is the tortillion that creates this drawing style. Practice drawing a value scale such as the smoothly blended one below, using your pencil and tortillion.

Be sure to build the dark area gradually, applying your pencil lines evenly, in the same direction, up and down. Lighten your touch as you progress to the right, lightening the tone as you go. Try to make the fade as gradual as possible without any separation in the tones, or choppiness, until the tone fades into the white of the paper.

A smoothly blended value scale from dark to light.

To blend, use a tortillion the same way you did the pencil, going over your drawing to blend the tones together. Use the tortillion at somewhat of an angle so you do not push in the point. Apply it in the same direction you applied the pencil lines, softening your touch until the tone fades into nothing.

You should not be able to see where one tone ends and another begins. If choppiness does occur there are tricks to fix it. First of all, squint your eyes while looking at your drawing. This helps blur your vision and allows you to see the contrasts in tone more easily. The dark areas will appear darker and the light areas will appear lighter. This makes any irregularities stand out. Should you see any unwanted

An incorrectly drawn value scale. Because of the scribbled application of pencil lines in this scale, it's impossible to blend it out evenly.

dark spots, take a piece of your kneaded eraser and roll it between your thumb and forefinger to create a point. Gently lift the dark spot out with the eraser by stroking it lightly. Never dab at it. I call this "drawing in reverse," since it's not just erasing but is actually a controlled technique. Should you see any little light areas that shouldn't be there, lightly fill them in with your pencil.

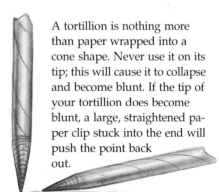

A tortillion is nothing more than paper wrapped into a cone shape. Never use it on its tip; this will cause it to collapse and become blunt. If the tip of your tortillion does become blunt, a large, straightened paper clip stuck into the end will push the point back out.

This is the proper angle for using a tortillion.

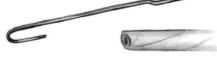

Since it is the blending that creates an object's shape, it's important to learn how to blend in a curve. Once you have mastered the blending scale, try blending in an arch or circular shape, as shown on page 21.

THE FIVE ELEMENTS OF SHADING

To apply blending and shading to your drawing you must understand that shading represents the tones of the object and how its color is affected by light and shadow. These tones are broken down into five elements and are best illustrated on a sphere. It is important to memorize these elements and the roles they play. They will apply to everything you draw.

The Five-Box Shading Scale

Each box in this scale represents one of the five elements of shading and displays how dark or light each should be. Look at the sphere and cylinder pictured here and observe all the elements of shading.

1. Cast Shadow. This will always be the darkest dark on your drawing. It is caused by the object itself blocking the light with its shape. It is always opposite the light source.

2. Shadow Edge. This is where the object curves away from the light; it is the area that shows the most roundness.

3. Halftone. This is the neutral area where the object is neither in bright light or shadow. It is halfway.

4. Reflected Light. This is always found along the edge of an object. It's caused by the light coming around from behind and bouncing up from the surrounding surfaces. It tells you there is a back side to the object. It is most noticeable in the shadow area where it separates the cast

shadow from the shadow edge. Without reflected light, all the dark areas would appear to run together, making the object appear flat.

5. Full Light. This is where the light is strongest. It tells you where the light is coming from, giving you direction.

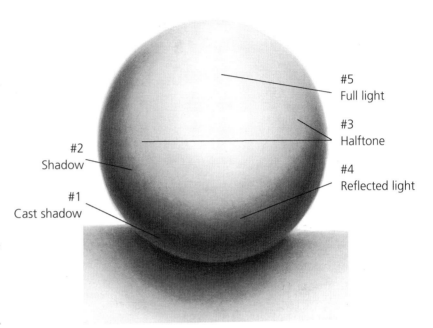

#2 Shadow

#1 Cast shadow

#5 Full light

#3 Halftone

#4 Reflected light

#1 Black #2 Dark Gray #3 Med. Gray #4 Light Gray #5 White

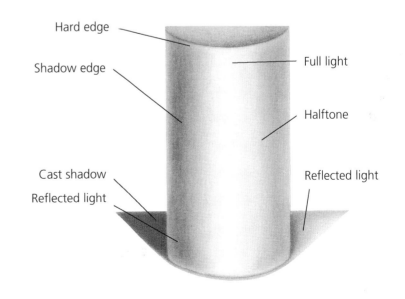

Hard edge

Shadow edge

Cast shadow

Reflected light

Full light

Halftone

Reflected light

BLENDING PROJECT

The five elements of shading are the most important things I teach. Without them nothing would look realistic. Of all the projects in this book, this is the one I would most recommend. Memorize the information here and do not advance until you are proficient and comfortable with your results.

Observe how the five elements of shading apply to both the sphere and cylinder. They will apply to any rounded object. My experience with teaching has proven to me that the two elements students most often leave out, and which I believe are the most important, are (1) reflected light and (2) the cast shadow. Ironically, these are the two most dramatic elements in sports illustration.

Sphere Exercise

Now it's time to put all this information to use. Let's begin with a simple sphere.

Cylinder Exercise

Use the same process to complete the cylinder. Use a ruler to keep the sides straight. Blend up and down with the tortillion, letting the tone fade gradually, keeping the value scale in mind as you work.

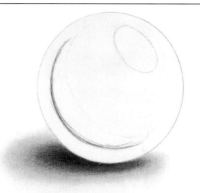

Use a stencil or template to trace a perfect circle. The light will be coming from the top right. This means the cast shadow will be under the left side. Be sure to keep a crisp edge along the side of the circle when applying the cast shadow or the circle won't look like a circle anymore.

Begin to place some tone to represent the shadow edge. Apply your pencil lines with the contour of the circle. Be sure not to take the tone clear to the edge—you must have some room for the reflected light. Reflected light is not white, but is a halftone.

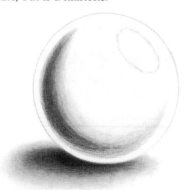

Continue to apply tone to the shadow edge, letting it lighten as it goes toward the light source.

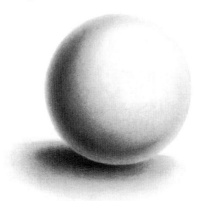

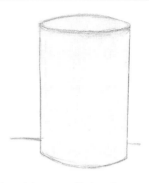

Begin with a pencil sketch.

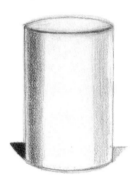

Apply pencil lines up and down.

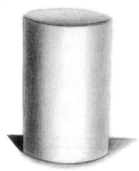

Blend up and down. Fade into the light area.

◄ With your tortillion, blend the tones out until they look smooth. Apply the tortillion as you did the pencil lines, with the contour of the ball. Now the empty circle is no longer flat but appears to have a three-dimensional form. To further enhance the realism, be sure to lighten any outline that may be around the edge. Allow shading to create an edge instead. Anything with hard outlines will look like a cartoon.

BENEFITS OF BLENDING

So why is all of this blending so important to sports illustration? Study all of these sports-related items closely. In them you will see what we have just studied.

The basketball and baseball are obvious spheres. But the way they are shaded makes them look different from each other. By darkening the basketball and adding the stripes around it, you have changed it from a sphere to a realistic basketball. The baseball is lighter in tone and has the braiding to describe it. Look how the smooth blending creates realism in both.

Cylinder and Egg Shapes

Since these two helmets are made to contour the shape of the human head, they are more egg-shaped than spherical. Again, the smooth blend is what makes them look hard and shiny. Look closely at the football helmet and you will also see the cylinder in the tubular shapes of the face mask.

The hand holding the baseball is also made up of basic shapes. Obviously the baseball is a sphere, but the fingers are made up of cylinders. The palm of the hand closely resembles a cube.

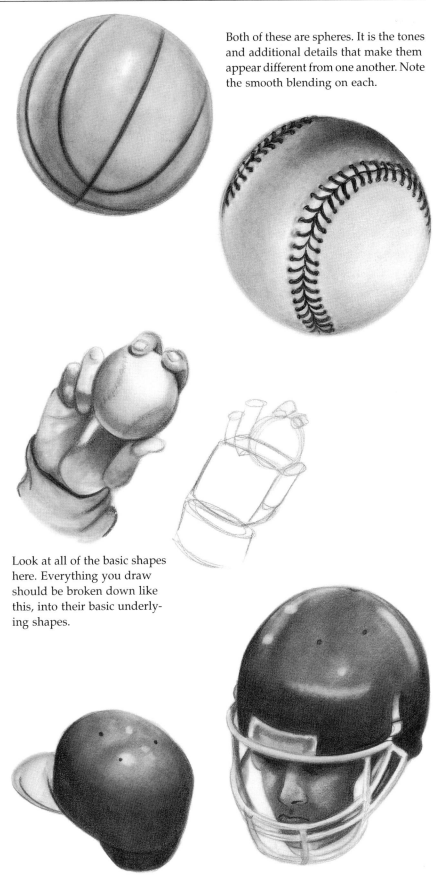

Both of these are spheres. It is the tones and additional details that make them appear different from one another. Note the smooth blending on each.

Look at all of the basic shapes here. Everything you draw should be broken down like this, into their basic underlying shapes.

Look for the egg shape here. Anytime you see the shape of the human head you'll find an egg shape. The face mask is made up of thin, tubular cylinder shapes.

DRAWING THE FIGURE

There are many ways to draw, from very tightly executed renderings to quick sketches. Gesture drawing is a quick method for capturing the body in motion. I use this drawing style for training my eye to see shapes while a figure is moving.

It is not meant for capturing a likeness or any small details. Rather it is a means of illustrating and recording shape and movement.

Quick, circular strokes are applied to the drawing paper while your eyes study the subject as it moves. Do not concern yourself with the small details, but pay particular attention to the following.

1. Proportions (the size of one thing compared to another)

2. Basic Shapes (underlying shapes: the cylinder, egg, etc.)

3. Movement (what direction are the shapes moving?)

This is a rapid drawing style, very quick and uninhibited. It's a very useful method when drawing from live action. A small sketchbook and pencil can transform any sporting event into an artistic experience. Although your images will appear somewhat scribbled and crude, drawing them will do wonders for training your eye to see shapes.

Since this book is two-dimensional, we will be working from photo references. However, gesture drawing is highly adaptable to pictures. Look at how shape and movement have been captured here. I took these examples from a magazine, as practice. To practice your figure drawing skills, collect as many sports photos and magazines as possible. A few quick gesture drawings whenever you can find the time will greatly improve your abilities. Remember: practice is everything.

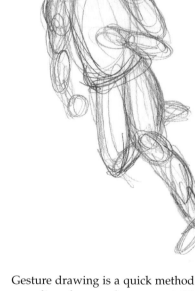

Gesture drawing is a quick method for recording shape and movement. It's a rapid drawing technique, using quick, circular strokes. Do not try to capture details.

LINE DRAWING

Now, having demonstrated its usefulness in capturing shape and movement, let's take gesture drawing a step further.

Line drawing is a more accurate method of capturing shapes. With this style you can begin to record some of the smaller details that are left out in gesture drawing.

Angles

We know that shapes are important, but the angles created by those shapes are of equal importance. Even rounded objects have subtle angles to them. If you can train your eyes to see these angles it will prevent your drawings from appearing too simplified.

Compare the two drawings at bottom right. Because of the many rounded areas on the football player, it would be easy to draw him too puffy. While I drew, I was careful to watch for the subtle angles illustrated in the other drawing. They make the figure seem more solid and rugged. A subject drawn too rounded will appear rubbery.

Tilt

Another thing to watch for is the tilt of your subject. When we draw we have a natural tendency to straighten things up, placing them vertically up and down. Look at the perpendicular lines that I drew to emphasize the tilt. By doing this you draw more accurately, creating more movement in your piece.

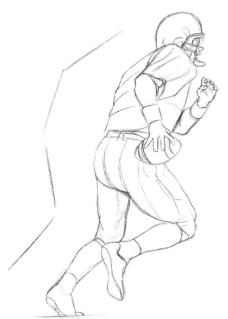

The tilt of this figure nearly resembles the shape of the letter *S*. Practice drawing all of these poses, first as gesture, then as line drawings. Watch for shape, angle, tilt and proportion.

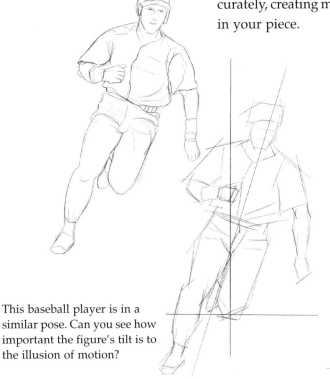

This baseball player is in a similar pose. Can you see how important the figure's tilt is to the illusion of motion?

Again, perpendicular lines will help you capture the tilt. Watch for the angles also, for more realism.

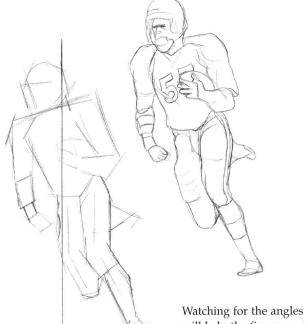

Perpendicular lines help emphasize the tilt of the figure.

Watching for the angles will help the figure appear more solid and less rounded and rubbery.

VARIATION

When drawing in line, it's important to vary your line width to help suggest shape. Thin lines are used in areas that are brightly lit, while thicker, darker lines are found in the shadow areas. Lines that are all equal in color and thickness will make your drawing look like a cartoon.

When practicing your freehand drawing, start by using a loose gesture approach. This will help you get the shapes, angles and tilt accurate. Then add more detail and smooth out and refine the lines for more realism. As you go, erase any working lines that are no longer needed and replace them with more solid line work.

Look for subject matter in sports magazines and newspapers. Draw as many of the pictures as possible. Practice, practice, practice!!!

Line drawing

Angles

Gesture drawing

Three drawings, three styles. Each one of these illustrations has been handled with a different approach, but all show the form in motion.

All three styles are important to developing your drawing skills. Even if you do not particularly like the look of each style, it's what you learn from practicing them that's important.

MULTIFIGURE DRAWINGS

Try combining more than one figure in your practice work. Look closely at these two illustrations for the way the figures work together. Size relationships are important. Notice how the figure closest to us appears larger than the one farther away. This is the effect of distance and perspective.

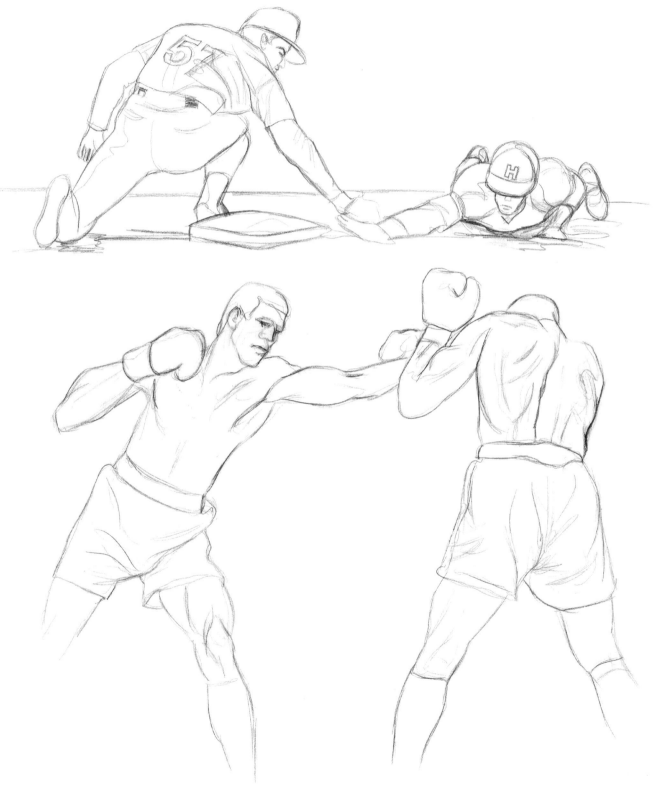

FORESHORTENING

For your figures to look authentic, you must be able to draw the human body in many positions. Sometimes the poses are simple, but sometimes they become quite complicated due to the positions the figures are in. Nothing can complicate the pose of the human form more than sports. Athletes will put their bodies into positions the average person would never dream of.

Look at the example on the opposite page. The upper body is fairly average, but look what happens to the view of the legs. Whenever something has an area that protrudes, or projects outward, you will encounter what is called foreshortening.

Foreshortening is a perspective term. It refers to an area that is projecting forward, giving the viewer a distorted impression of the shapes. In this illustration, the athlete's legs are coming forward. Because of this, the full distance and length of the leg is not visible. What you see is the front, or feet, and the upper leg. The area in between is distorted and appears much shorter than it normally would.

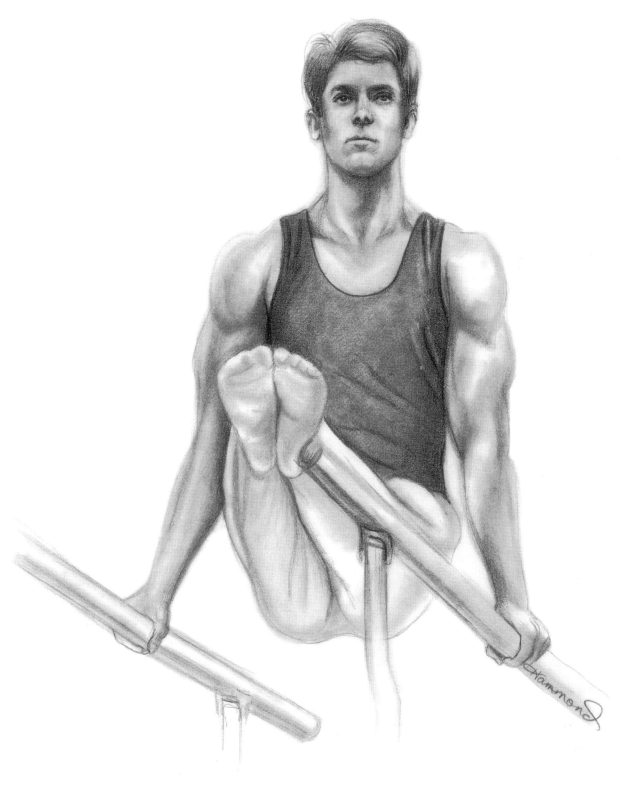

The legs, projecting forward, create foreshortening.

FORESHORTENING SIMPLIFIED

Let's study foreshortening in simple terms. Look at these basic shapes. When looking at the cylinder from the end all you see is the circle shape. The entire length of it is completely blocked from view.

From a semi-turned position you can begin to see the side of the cylinder and how it looks like it has some length.

But when compared to the full profile view, you can see how the second cylinder seems shorter than the third. The full profile shows the entire length. Can you see how this perspective applies to the legs of the gymnast on the previous page?

The cylinder viewed from the end, where its length cannot be seen, looks like a circle.

As you turn it slightly it takes on some dimension.

A full profile shows the entire length of the cylinder.

ARMS IN PERSPECTIVE

If things are viewed from the side they are easier to draw. Let's look at the effects of foreshortening on these arms. The first illustration was much easier for me to draw because the entire length of the arm was visible. There is a lot of psychology that goes into drawing—if we can't see something the way we remember it, we try to fill in the blanks. That's one of the reasons drawing can be so difficult. You must always draw what you see, not what you think you know. By drawing from memory we do not draw things accurately.

This athlete has his arms going in two different directions. Look how much shorter the arm on the

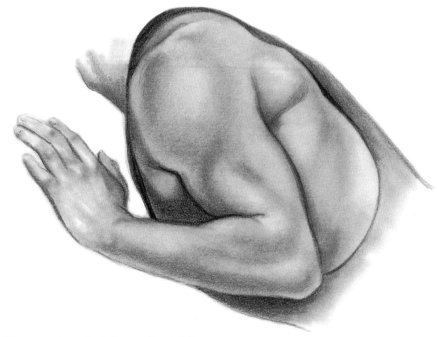

The entire length of the arm is visible in this view, making it much easier to draw.

right appears. This is because the forearm is coming toward us and we cannot see the length of the arm from elbow to wrist.

These two poses are similar, but one arm is going off to the side and the other is coming straight at you. Can you see the difference it makes?

The perspective is most evident where one surface overlaps another. Look at the way the hand is blocking the shoulder in one, and the arm is blocking the chest in the other.

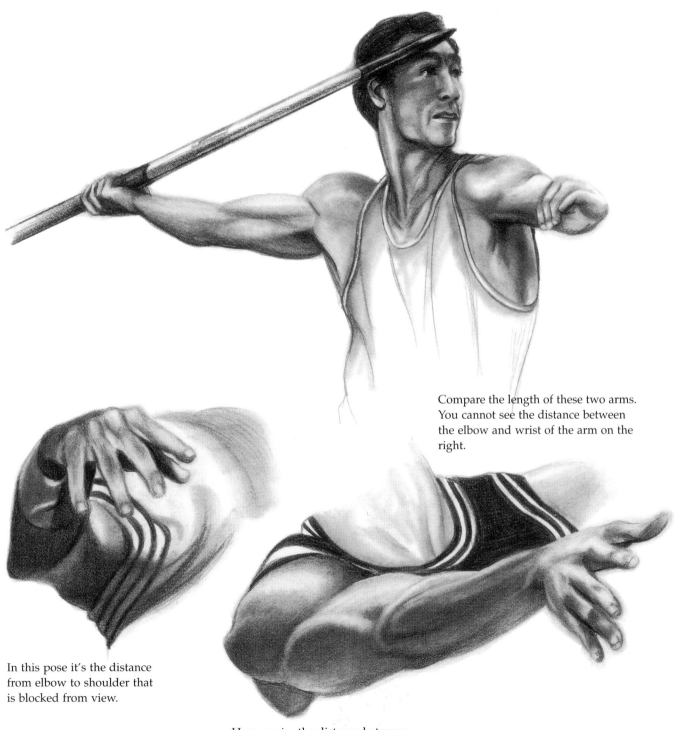

Compare the length of these two arms. You cannot see the distance between the elbow and wrist of the arm on the right.

In this pose it's the distance from elbow to shoulder that is blocked from view.

Here, again, the distance between elbow and shoulder is distorted.

HOW IT AFFECTS THE BODY

Let's see how foreshortening can apply to the entire body. These two drawings demonstrate how different a subject can look when drawn in line and when shaded. The perspective is obvious here. With the back arched backwards, the chest of the diver completely blocks the head and neck.

It is always amazing to me how much more dimension a drawing can have with the use of blending and shading. A line drawing will always seem flatter. Also, the shaded background gives the illusion of a separate surface behind the diver. That also gives the drawing more depth.

Look how I used shading to create the muscle contours and the lighting.

In this drawing the diver is not in a foreshortened view. The entire length of the body is visible, even though it is in a tucked position.

A line drawing looks less dimensional. Look at the perspective here. The chest completely blocks the neck and head from view.

Shading and blending give this drawing realism. Further depth is created by adding tone behind the diver.

◄ This view is not foreshortened. The entire length of the body is visible.

EXTREME FORESHORTENING

Both of these baseball players are extreme examples of foreshortening. In the first illustration, the player's stance completely eliminates the entire length of the torso and chest areas. He appears to be all shoulders, arms and legs.

The second example is even more drastic in its perspective; not only is the chest area blocked, but the entire length of the legs is missing. All you see is a glimpse of the player's feet. What also makes this an interesting drawing is the shadow underneath the figure. The extreme darkness of the cast shadow contrasts severely against the light seen on the back. This creates a good solid sense of the sun and light direction. Experts say, in all good art it's not just the subject that makes it art, but more the effect of light on the subject.

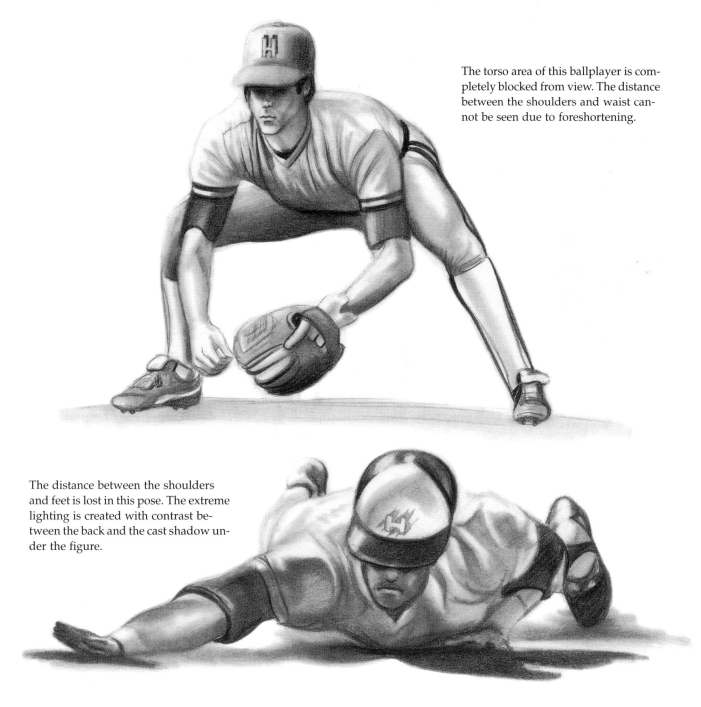

The torso area of this ballplayer is completely blocked from view. The distance between the shoulders and waist cannot be seen due to foreshortening.

The distance between the shoulders and feet is lost in this pose. The extreme lighting is created with contrast between the back and the cast shadow under the figure.

THE FORESHORTENED LEG

Understanding foreshortening does not come easily. It is a constant battle with our minds trying to draw what we see. You must take the time to truly study your subjects to understand perspective completely. I taught myself to draw. It wasn't easy and took years of constant practice, observation and study. I drew as much, and as often, as possible. These two examples resemble the type of drawings I did for practice.

Instead of drawing an entire figure, I selected just a portion and studied it completely. I invite you to do the same. Do not worry if you do not have good results every time. I still have trash cans in my studio and throw away many drawings. It's all part of the learning process.

Let's study these two leg drawings together. Can you see how different they look due to their pose? One similarity is the extreme shadows caused by the overlapping surfaces. This is what makes sports illustration so dramatic. Look at the shadows of one leg going across the other. Look for the light source and the contrasts it creates. These may just be drawings of legs and feet but, artistically, I think they are beautiful.

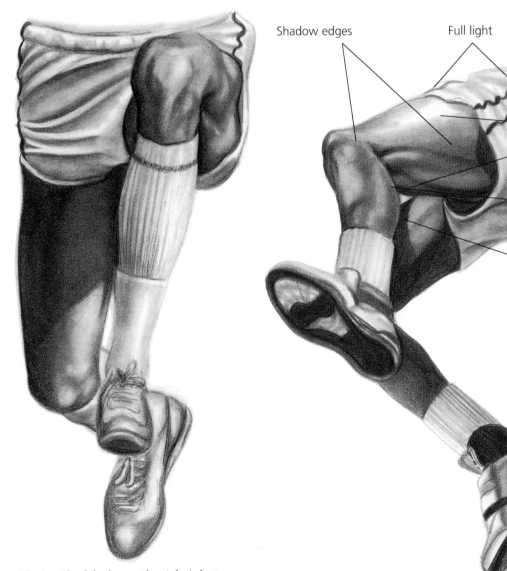

Shadow edges

Full light

Halftones

Reflected light

Cast shadow

The length of the leg on the right is lost due to perspective while its shadow crosses the leg on the left.

Look closely at the extreme contrasts of light against dark, and dark against light.

EQUIPMENT IN PERSPECTIVE

Perspective affects everything, not just the body. Be sure, when drawing sports, that you take the sports equipment into consideration also. Take these two views of the tennis racquet, for example.

The first view shows the racquet in its entirety. It gives you a good look at its shape and size and the size relationship with the arm.

The second view, however, is a perspective shot where the length of the handle is not visible. You see more of the side, and its size in relationship to the arm is now distorted.

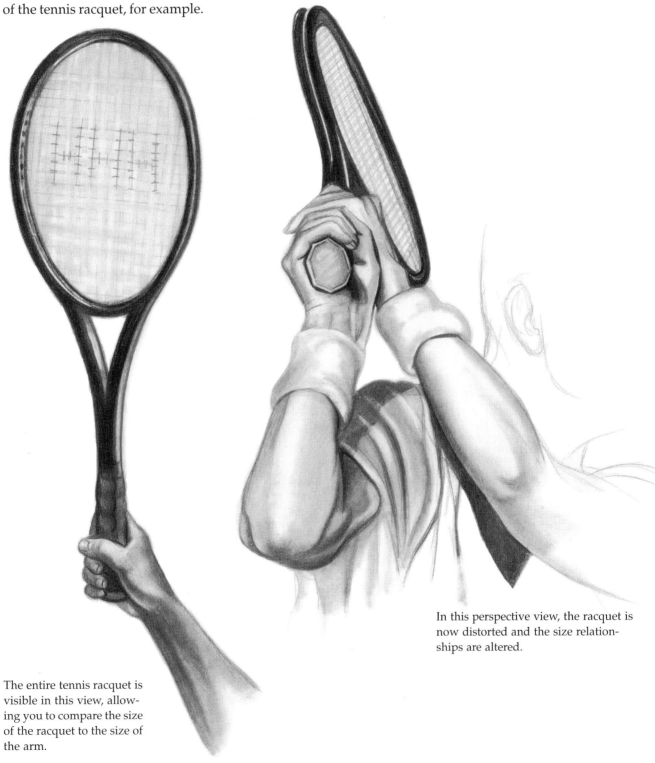

The entire tennis racquet is visible in this view, allowing you to compare the size of the racquet to the size of the arm.

In this perspective view, the racquet is now distorted and the size relationships are altered.

FORESHORTENING EXERCISE

This three-step demonstration shows you how I create a drawing. This is also another good example of foreshortening seen in an action pose.

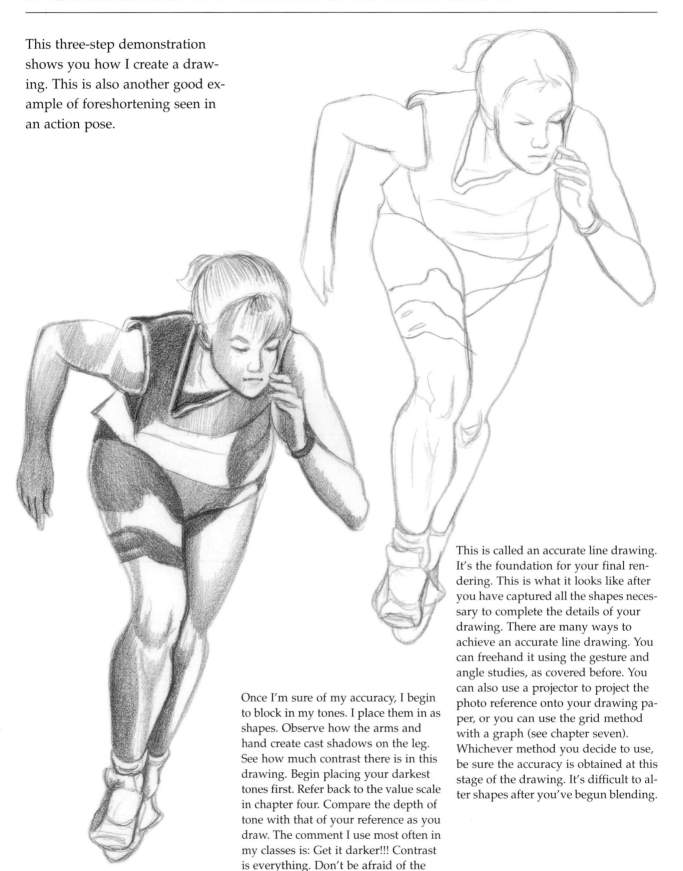

This is called an accurate line drawing. It's the foundation for your final rendering. This is what it looks like after you have captured all the shapes necessary to complete the details of your drawing. There are many ways to achieve an accurate line drawing. You can freehand it using the gesture and angle studies, as covered before. You can also use a projector to project the photo reference onto your drawing paper, or you can use the grid method with a graph (see chapter seven). Whichever method you decide to use, be sure the accuracy is obtained at this stage of the drawing. It's difficult to alter shapes after you've begun blending.

Once I'm sure of my accuracy, I begin to block in my tones. I place them in as shapes. Observe how the arms and hand create cast shadows on the leg. See how much contrast there is in this drawing. Begin placing your darkest tones first. Refer back to the value scale in chapter four. Compare the depth of tone with that of your reference as you draw. The comment I use most often in my classes is: Get it darker!!! Contrast is everything. Don't be afraid of the dark areas.

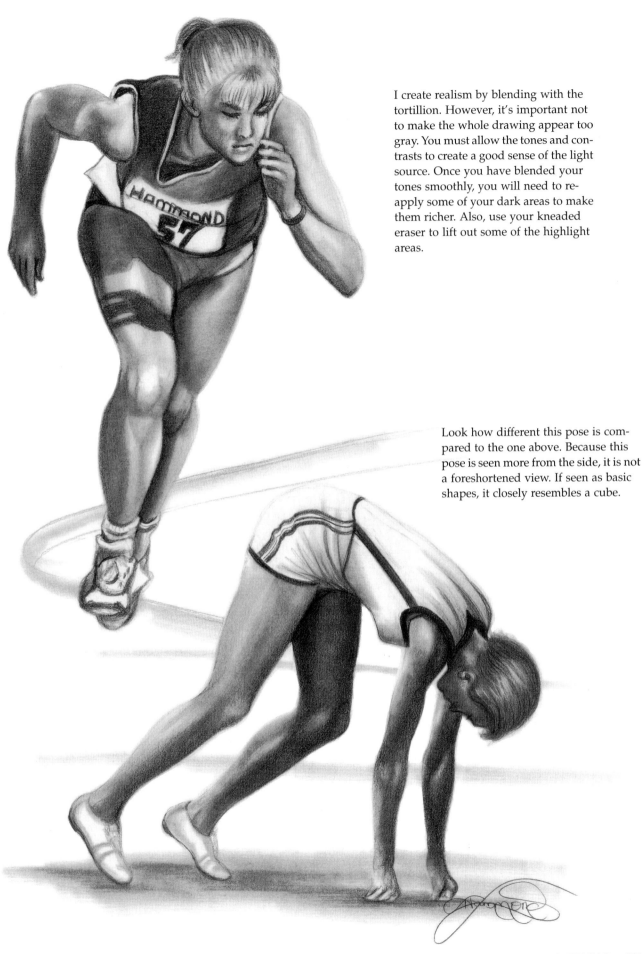

I create realism by blending with the tortillion. However, it's important not to make the whole drawing appear too gray. You must allow the tones and contrasts to create a good sense of the light source. Once you have blended your tones smoothly, you will need to reapply some of your dark areas to make them richer. Also, use your kneaded eraser to lift out some of the highlight areas.

Look how different this pose is compared to the one above. Because this pose is seen more from the side, it is not a foreshortened view. If seen as basic shapes, it closely resembles a cube.

GRAPHING

To draw anything with accuracy, you must break it down into small, interlocking shapes. Each shape must be correct in size and shape. Graphing is an excellent tool for achieving this.

Graphing is a method of placing a grid over a photo reference. It divides the image into smaller, more manageable shapes. It also helps you to see the image more objectively. The grid forces you to pay attention to the shapes contained within the small boxes. Instead of looking at the reference as a subject, you are drawing it as nothing more than inanimate shapes. Let's start with these drawings of a golfer and a baseball player.

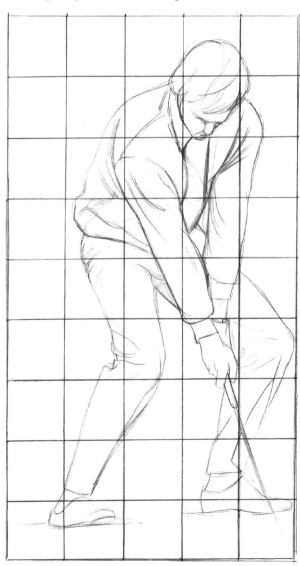

I used this graphed line drawing to achieve my accurate line drawing at right.

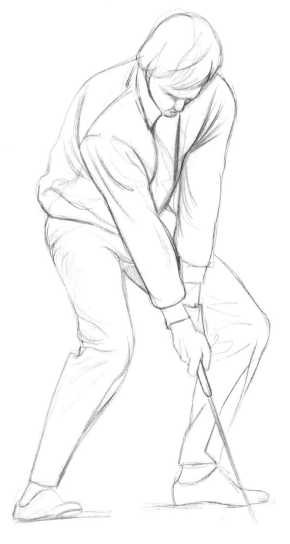

By following the shapes within the grid, I was able to replicate the drawing on the left.

THE GRID

To practice drawing with a grid to replicate the drawings of the golfer and baseball player, you must first place a light grid on your drawing paper. Note that I said light. This is important as the graph lines must be erased completely when the line drawing is completed.

It is also important that all your grid lines are perfectly straight. Any inaccuracy in the graph will show up as a distortion in your drawing. Take time with your ruler!

Draw slowly, paying attention to how the grid lines divide the subject matter. Draw only the shapes you see within each box, one box at a time. Forget what it is you're drawing and see it as puzzle-piece shapes inside little boxes. This will make it so much easier and your drawing will be more accurate.

Hint: You can use a graph to enlarge or reduce a drawing. To enlarge what you are drawing, make the boxes of your graph larger on your drawing paper than they are on your reference. If you place a ½-inch graph over your subject matter, a 1-inch grid will make the drawing twice as large. To reduce the drawing, make the graph on your paper smaller.

I suggest you make various graph overlays in various sizes. These can be made with a permanent marker on an acetate report cover or computer generated and printed on transparencies.

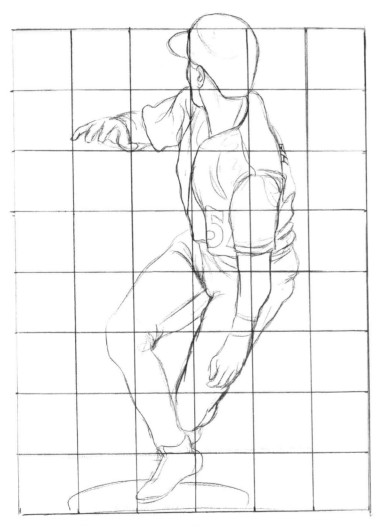

Use this gridded drawing for practice.

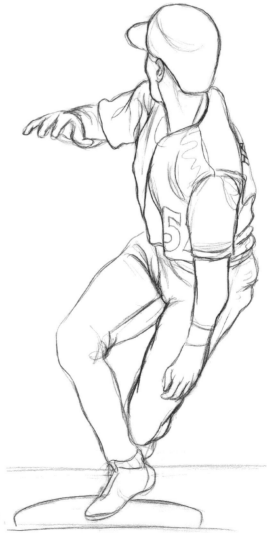

When finished, your line drawing should look like this.

GRAPHING EXERCISES

Here are two more graphing exercises for you to practice. Be sure to go slow and draw as accurately as possible. Practice reducing or enlarging these projects. Also, take one of your acetate overlay graphs and place it over some magazine pictures. See how you can obtain a line drawing from an actual photograph.

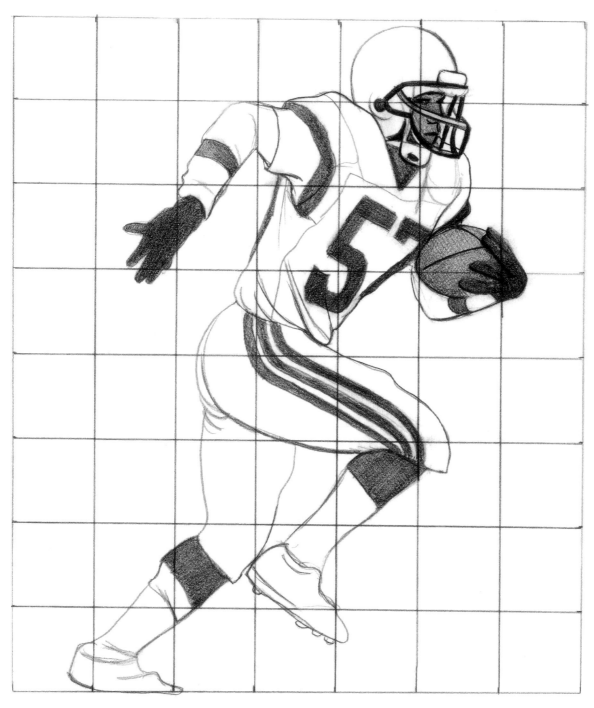

The tones in this drawing of a football player should be seen as shapes when you're drawing.

This drawing has a lot of folds and ▶ creases in the clothing, so pay attention to the direction of the lines.

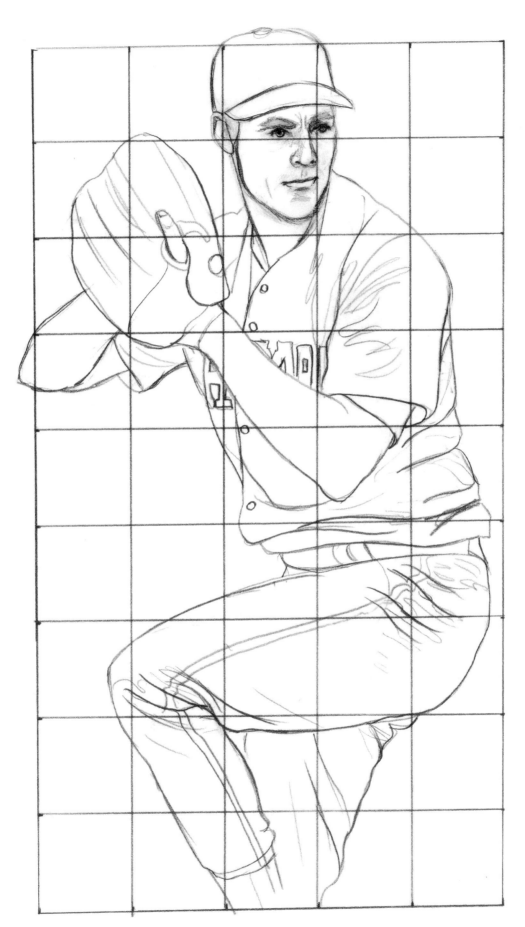

THE GOLFER

For this drawing of the golfer I used a smaller graph to help isolate some of the smaller details.

Once my line drawing was accurate, I removed the graph lines from my drawing paper with a kneaded eraser.

I then began to place in the tones, starting with the darkest ones first. Always look for the shadow areas and put them in first.

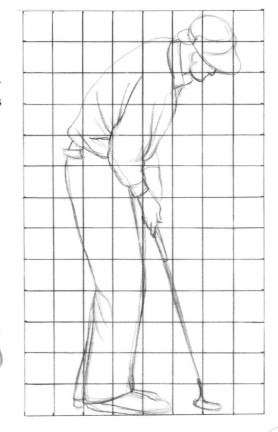

Use this graphed line drawing for practice work.

◄ When you are sure your drawing is accurate, remove the graph from your paper with a kneaded eraser.

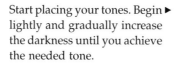

Start placing your tones. Begin ► lightly and gradually increase the darkness until you achieve the needed tone.

IT'S ALL IN THE DETAILS

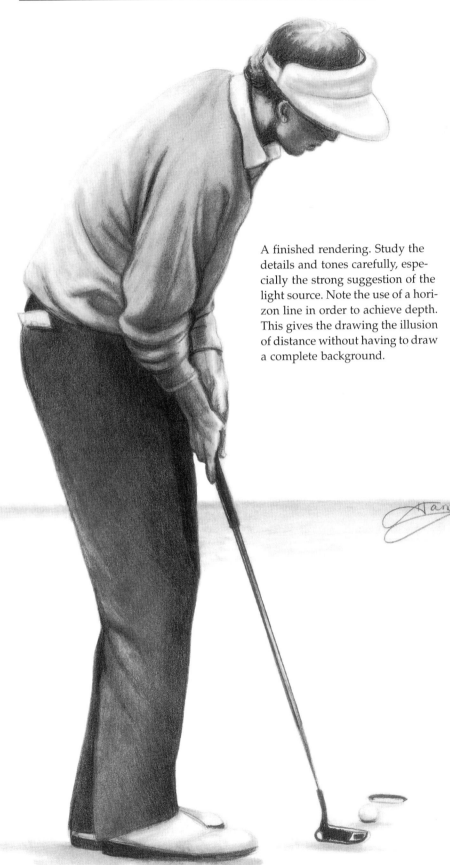

A finished rendering. Study the details and tones carefully, especially the strong suggestion of the light source. Note the use of a horizon line in order to achieve depth. This gives the drawing the illusion of distance without having to draw a complete background.

This is what the finished drawing should look like, enlarged here so you can see and closely study the details.

Look carefully at the clothing—see how the creases and folds of the fabric help illustrate the movement of the figure. Look at the area where the arms overlap one another. Can you see the five elements of shading there? There is a shadow behind the arm in front, and there is an edge of reflected light going down the sleeve.

See how pronounced the light source is from the left. The whole back of the sweater is very light. After I blend my drawings I am always careful to lift the light back out with a kneaded eraser.

The pants here are very dark. Sometimes, after blending, dark areas can seem to be pale again. Just keep reapplying your tones and reblending until your tones are dark enough again. Also, when you spray your finished drawing with workable fixative, your tones will darken. If they don't, however, you can reapply tones on top of the spray and spray again (that's why it's called workable).

I tried to create some depth by adding a horizon line, the cup for him to putt into and shadows beneath him and the club.

THE CATCHER

Let's try this step-by-step drawing of a baseball catcher. Follow the procedure as closely as possible; take your time.

First decide how large you want your drawing to be. Then, with a ruler, lightly place a grid on your drawing paper. Be very accurate, making sure all the boxes are perfect squares.

One box at a time, replicate all the shapes you see in my line drawing. Don't stop until you're sure everything is accurate in size and shape.

When you are satisfied with your drawing, gently remove the graph with your kneaded eraser.

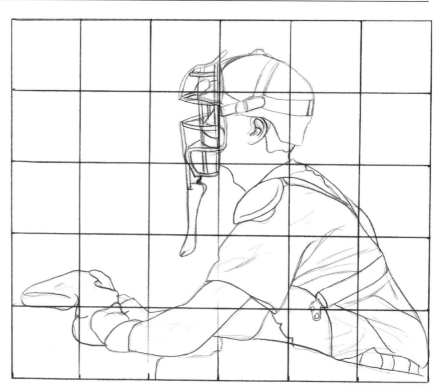

Draw this catcher using the grid method.

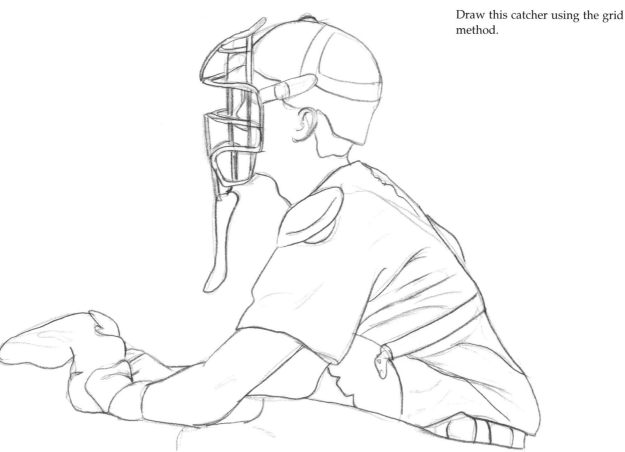

This is what your accurate line drawing will look like when your graph lines are removed.

Positive and Negative Shapes

Begin to place your values, starting with the dark tones. Look closely at the face mask. Allow the small dark shapes to create the small light shapes. These areas are called positive and negative shapes. The positive shapes are the actual object you're drawing. The negative shapes are the areas surrounding it. It is easier to draw the dark, or negative, shapes because they are larger, and you should always draw them first.

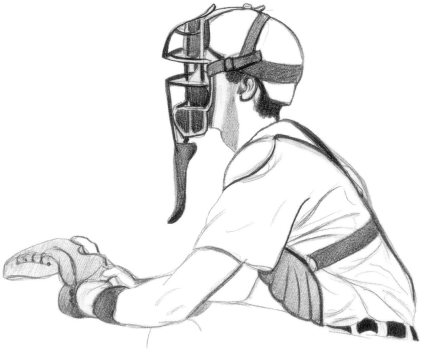

Begin placing the values, from dark to light. Look for positive and negative shapes. Allow the negative shapes to help you with the small details of the face mask.

Blend

With a tortillion, blend your tones until they are smooth and even. Create the folds and wrinkles of the shirt. Watch carefully how the light plays off the ins and outs of the fabric creases. Always be sure to create a good sense of your light source.

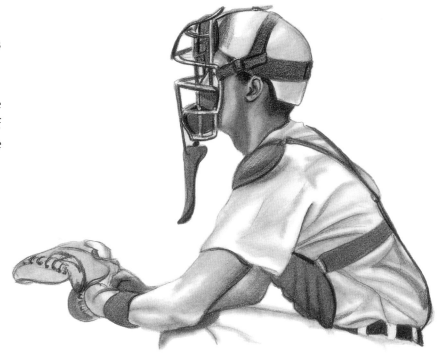

Blend out the drawing with a tortillion. Create the details of the clothing. Show a strong light source with your tones.

THE BASKETBALL PLAYER

The same procedure can be used to render this basketball player. As you can see, he is not as complicated as the catcher. Draw your graph and create an accurate line drawing.

Refer to the previous exercises for help or examples. Remember, go slow; train yourself for accuracy!

Establish Light and Shadow

When you have drawn all the shapes accurately, completely erase your graph. Begin to apply your dark tones to establish the light source. In this case the lighting is coming from the upper left. Look how the shadow areas create the muscle shapes. Study the shoulders and upper arm. Can you see the anatomy created by applications of the tone? Watch for cast shadows, such as the one cast on the chest and under the arm.

To create the texture in the hair, apply your pencil with tiny, circular strokes. The hair is darker closer to the head, then fades, looking more transparent as it works out to the edge.

Use the same procedure to create this basketball player.

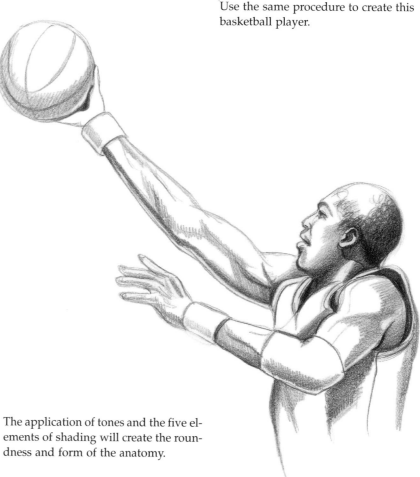

The application of tones and the five elements of shading will create the roundness and form of the anatomy.

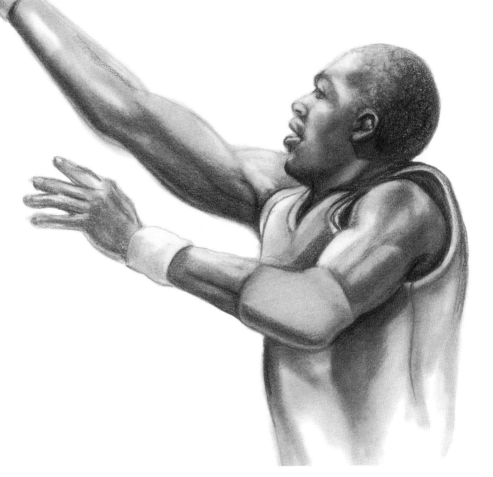

Blend to Finish

Finish your drawing with blending. Remember, it's the smoothness that makes this technique work. Use your kneaded eraser as a drawing tool to lift out highlights on the skin, clothes and hair. Look for areas of reflected light, especially on the arms; that is what gives them their roundness. Remember the cylinder exercises.

Remember the cylinder exercises when drawing the arms.

THE FIGURE SKATER

Don't forget the importance of angles even when using a graph to achieve your line drawing. Without seeing the angles, certain shapes are hard to draw in proper proportion. Perspective makes this skater's leg difficult to draw. The slight forward projection makes it a victim of foreshortening. By noting the angles, seen in the second drawing, this pose is easier to capture.

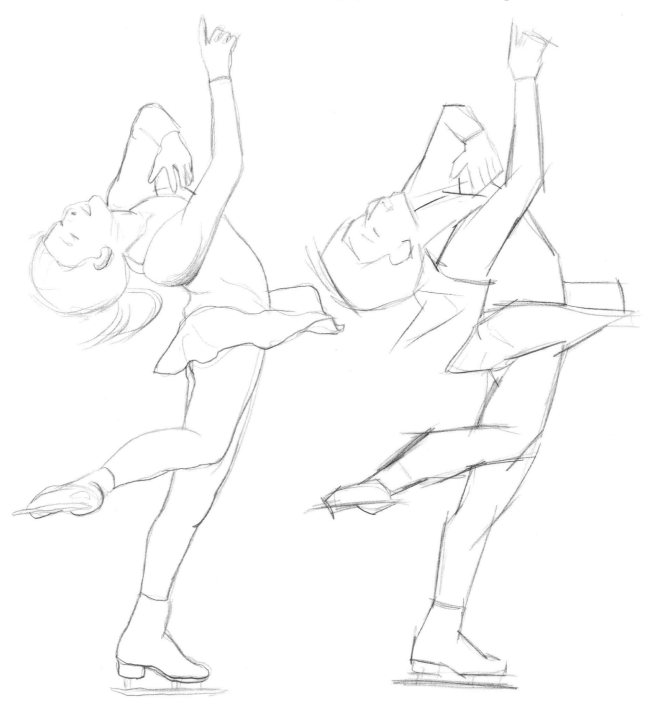

An accurate line drawing

Look at the angles to help you with perspective.

YOUR TURN

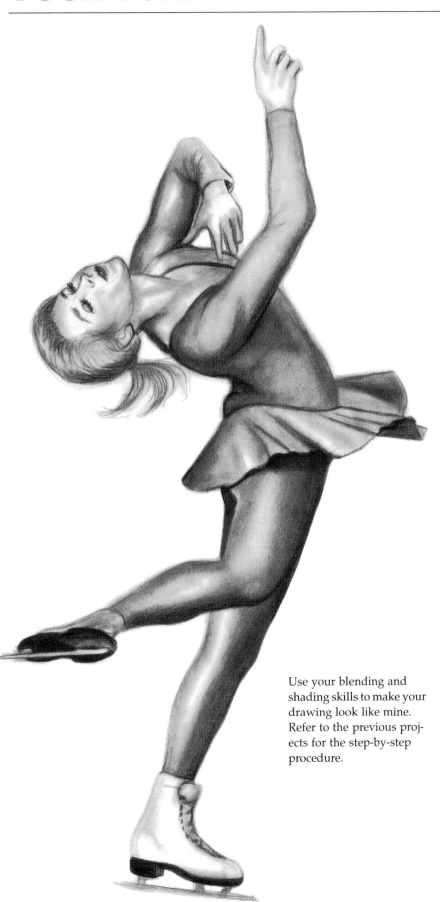

With this exercise, try applying what you've learned so far. Place an acetate graph over the line drawing. Refer to the angle illustration as you create your accurate line drawing. When happy with your shapes, remove your grid lines and try to render the drawing to look like mine. Remember to start with the dark tones and blend to light. Lift highlights where necessary.

Use your blending and shading skills to make your drawing look like mine. Refer to the previous projects for the step-by-step procedure.

THE GYMNAST

Here are two more graph exercises. The gymnast is divided with a 1-inch graph because the shapes are simpler and easier to see as puzzle pieces. The football player, on the other hand, is divided with a ½-inch grid due to its complex detail. The clothing, stripes and numbers make it harder to achieve accuracy. Dividing the image into smaller areas leaves less room for error.

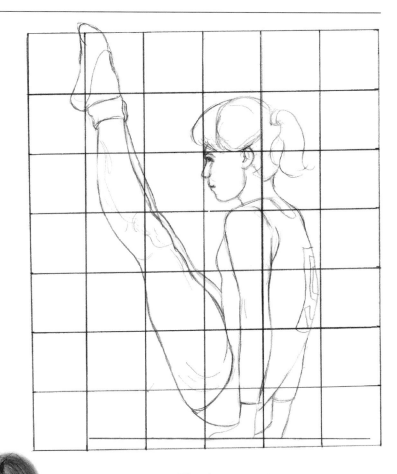

This drawing is divided with a 1-inch graph.

Carefully blend and shade to create this illustration. Pay particular attention to the shadow edges and reflected light in the muscle structure.

THE FOOTBALL PLAYER

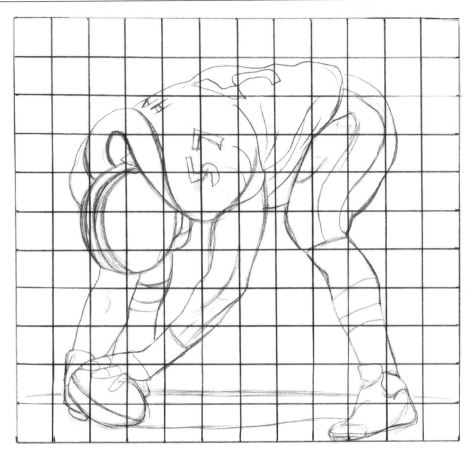

This drawing has been divided into ½-inch squares. This gives you less room for error when drawing small details.

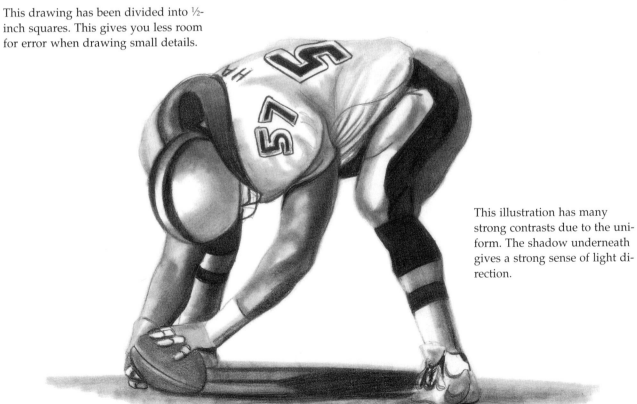

This illustration has many strong contrasts due to the uniform. The shadow underneath gives a strong sense of light direction.

DRAWING HANDS

Although we have not talked much about them until this point, hands are one of the most expressive elements in sports illustration. Go back and look at some of the previous drawings you have done and I bet you'll find the hands need some work. Am I right? If you want to be a sports illustrator (or draw any figure-related art), you must teach yourself how to draw hands.

The following is a quick overview of how to draw hands. For more information and in-depth study, I stongly suggest referring to my book *Draw Real Hands!* (North Light Books, 1997).

Each of the following poses show the hands in different sports-related functions.

This hand is in the process of pushing the ball. Much of it is hidden by the basketball, but the parts that do show are important. If not drawn correctly, the size relationship to the ball will be distorted. Look at the shadow of the ball across the hand, with the bright band of light right below it. This combination of lighting, action and overlapping shapes is typical of sports illustration.

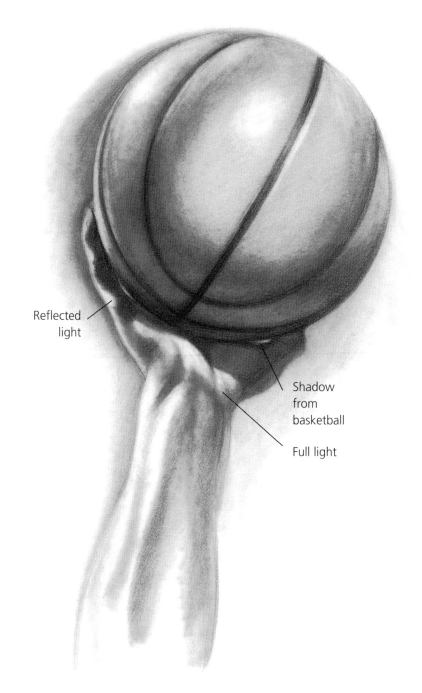

Reflected light

Shadow from basketball

Full light

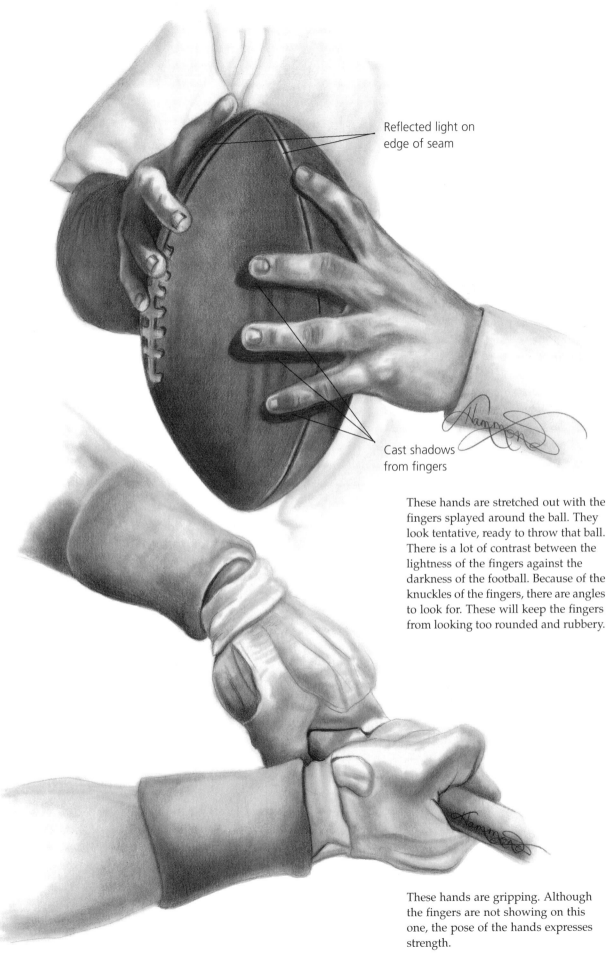

Reflected light on edge of seam

Cast shadows from fingers

These hands are stretched out with the fingers splayed around the ball. They look tentative, ready to throw that ball. There is a lot of contrast between the lightness of the fingers against the darkness of the football. Because of the knuckles of the fingers, there are angles to look for. These will keep the fingers from looking too rounded and rubbery.

These hands are gripping. Although the fingers are not showing on this one, the pose of the hands expresses strength.

THE SPORTS HAND

As with the figure drawing we've studied, you must watch for angles in the hands. Due to the bone and tendon structure they are not as rounded as you may think. Instead they are squared off in places.

These two poses are common in sports illustration. They give the impression of reaching. Look at the angle illustrations and you can see how many angles there are in a hand.

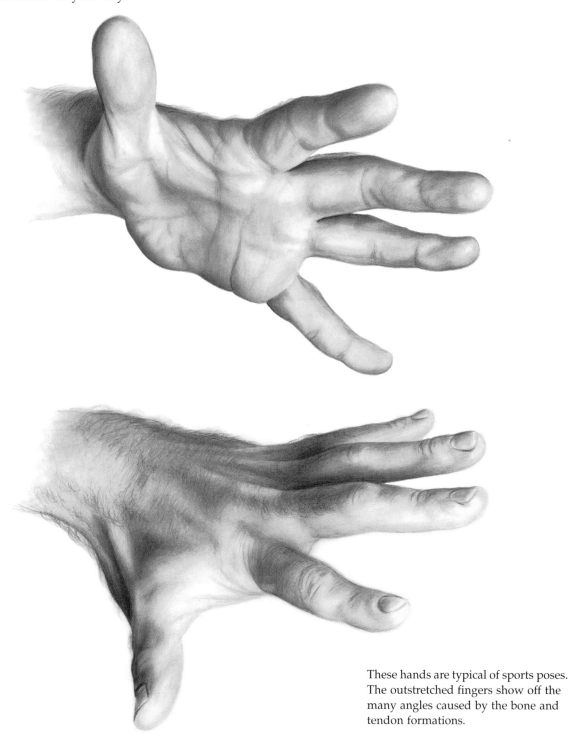

These hands are typical of sports poses. The outstretched fingers show off the many angles caused by the bone and tendon formations.

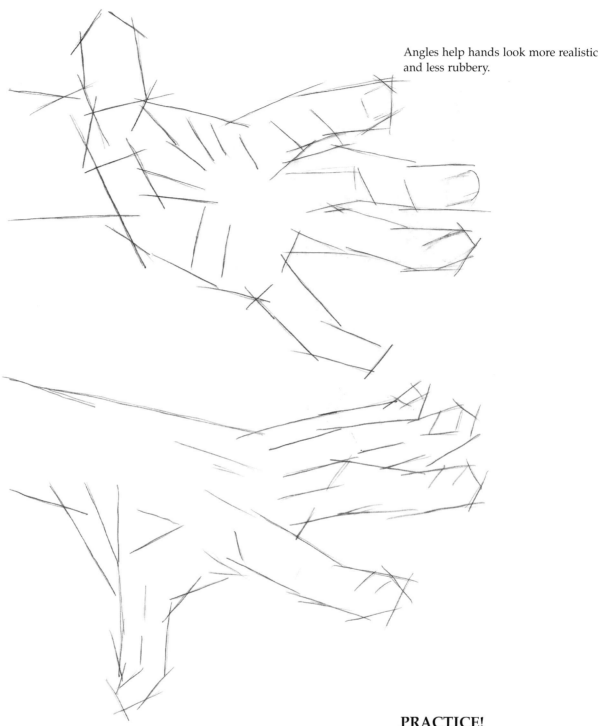

Angles help hands look more realistic and less rubbery.

PRACTICE!

Gather as many references and photos of hands as possible. Look in magazines and study various poses. Practice will be everything. The more you do, the better you will become. There is no such thing as a sports illustrator who doesn't know how to draw hands.

HAND EXERCISES

Once again you'll find graphing an indispensible tool for achieving proper proportions in your artwork. These graphed examples of hands will be good practice pieces. Study them carefully.

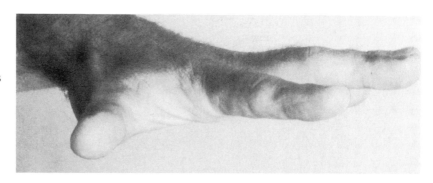

This outstretched hand is an extreme example of foreshortening. It is also a good example of how lighting can affect the look of an object. The lighting here is coming from below, making the top of the hand appear quite dark.

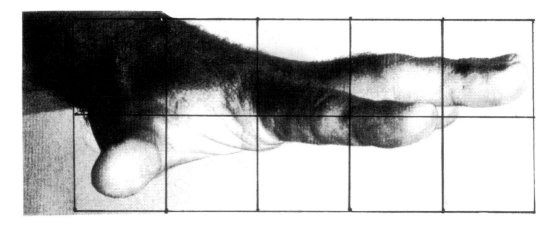

Graphing the photo will help you achieve the right proportions, especially the length of each finger. Notice the distorted view of the thumb and how short it appears.

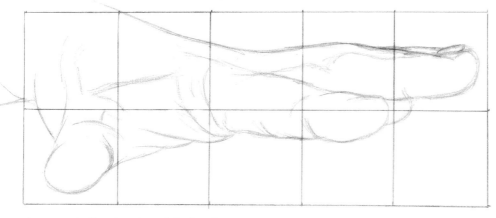

An accurate line drawing of the hand.

THE FORESHORTENED HAND

Foreshortening is a common dilemma when drawing hands. The hand is made up of several protruding elements and each can face a different direction at once. Not to mention that fingers that are pointing toward you will appear shorter than the others. These two graphed exercises will help you see all the trouble spots associated with the hands.

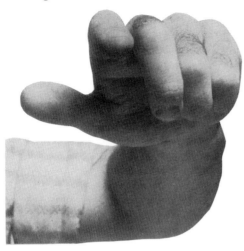

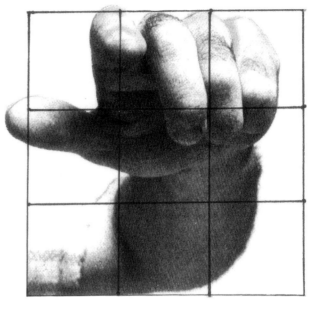

All of the fingers in this pose are foreshortened. Because of the way the hand is being held, with the fingers bent, the fingers take on a boxy appearance.

▲ This graphed example shows the foreshortening. Look at how small the forearm appears. It's almost smaller than the hand itself.

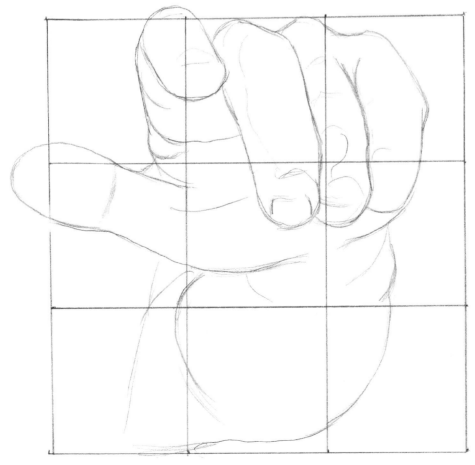

An accurate line drawing.

DRAWING SPORTS CLOTHING

Movement is a key element in sports illustration. Most sports have their own uniform or clothing type, and this clothing is highly affected by the action and movement of the body wearing it.

This is a quick introduction to what to look for when drawing clothing. For a more detailed study, refer to my book *Draw Fashion Models!* (North Light Books, 1998).

Whenever a piece of clothing has a pattern to it, that pattern will be altered by the way the clothing is being stressed. Every stripe in this baseball uniform is altered by the body's movement.

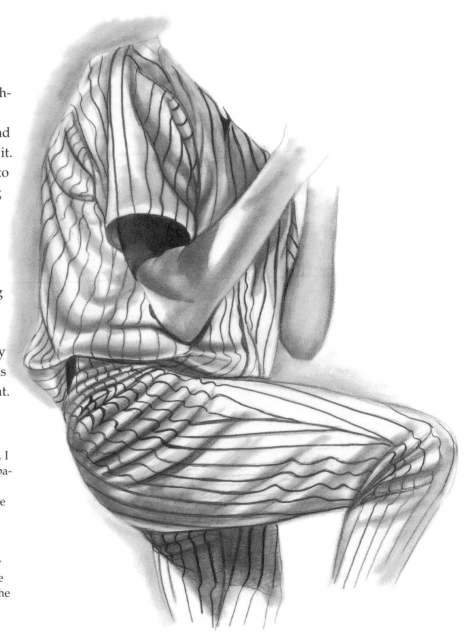

Since this uniform is basically white, I placed some shading behind it to separate it from the background. Every stripe in the uniform is altered by the movement of the body. I shaded the shadows first and established the creases and folds. The stripes were added on top. I studied them closely while drawing them in, to make sure they followed the contours of both the body and the creases of the fabric.

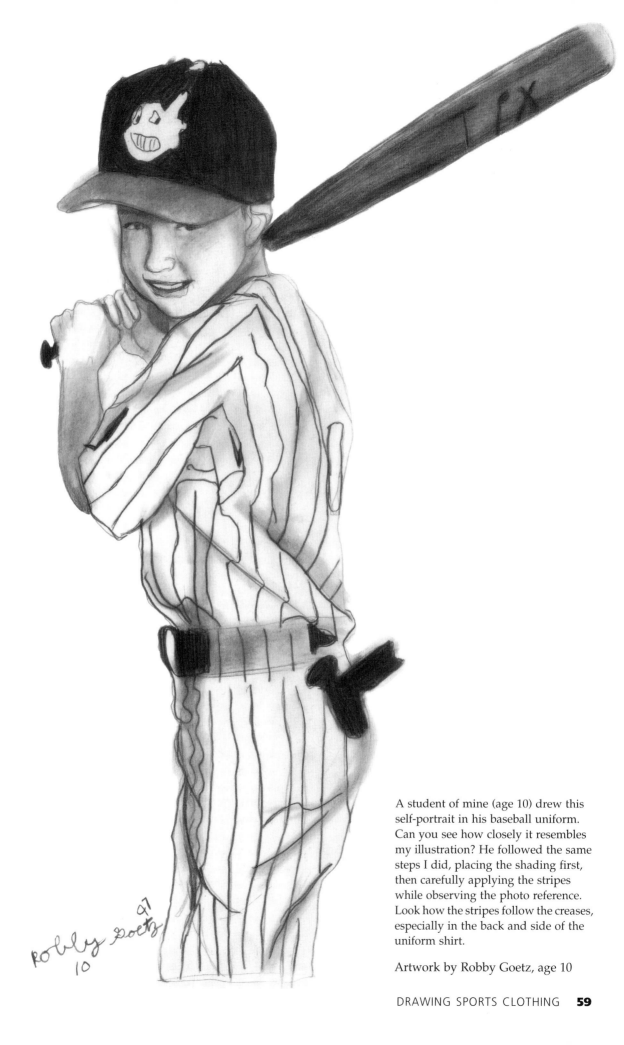

Robby Goetz
10

A student of mine (age 10) drew this self-portrait in his baseball uniform. Can you see how closely it resembles my illustration? He followed the same steps I did, placing the shading first, then carefully applying the stripes while observing the photo reference. Look how the stripes follow the creases, especially in the back and side of the uniform shirt.

Artwork by Robby Goetz, age 10

LIGHT AND SHADING

Even when clothing doesn't have a definite pattern, shapes of light and dark are created by the light source. You will see the five elements of shading everywhere the fabric is folded or creased. The tubular shapes of some folds have the same principles we saw in the cylinder, while the rounded shapes in the shoulders follow those we saw in the sphere exercises.

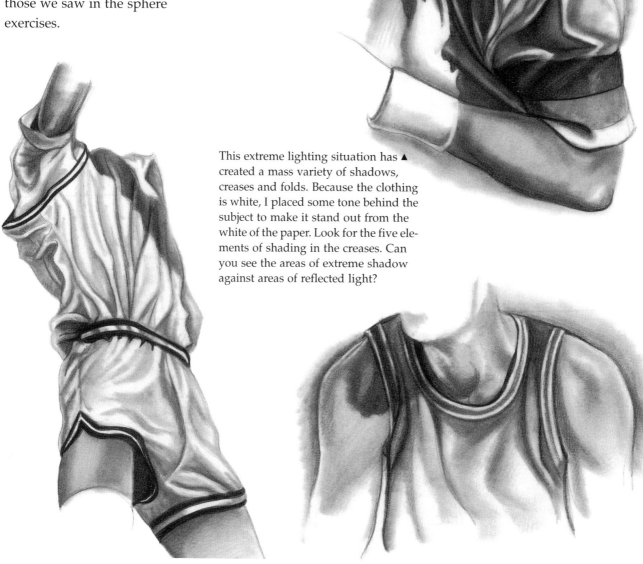

This extreme lighting situation has ▲ created a mass variety of shadows, creases and folds. Because the clothing is white, I placed some tone behind the subject to make it stand out from the white of the paper. Look for the five elements of shading in the creases. Can you see the areas of extreme shadow against areas of reflected light?

This uniform is riddled with creases, clearly demonstrating how much action is taking place. Look at how the shirt tucks into the shorts and how the shadow of the arm cuts across the chest. The smooth blending portrays the softness of the material. This is another fun one to draw.

Without the soft creases in this tank top it would appear flat. It is the movement depicted in the fabric that gives it life. Again, I placed tone behind the subject for definition.

STRESS FOLDS

In this illustration, both positions of the figures create stress folds in their clothing. Even though the umpire doesn't have the same stripes to deal with, there are still many creases and folds to be addressed. This is a fun one to draw. Place one of your graphs over it and see how you do.

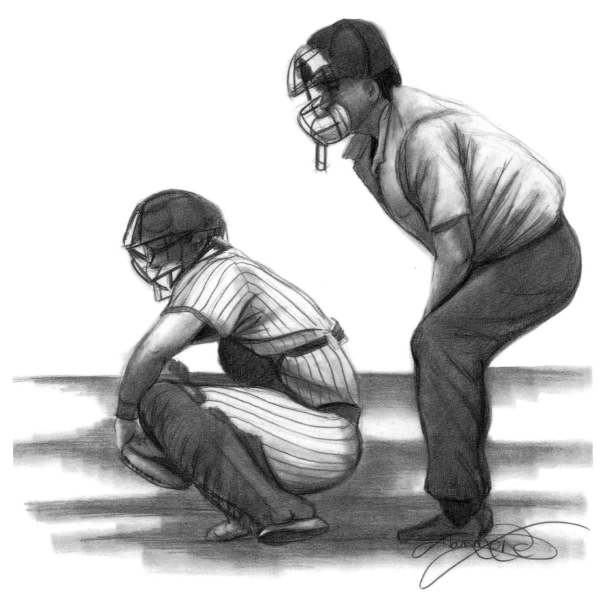

Place a graph over this illustration and try drawing it. Pay particular attention to the clothing—notice how the fabric creases show movement and the patterns follow the contours of the figure. Be aware of the light source, which is from the upper right. Shading under and behind creates distance.

PUTTING IT ALL TOGETHER

This pose takes in many of the complex problems we've covered so far. It's this type of body movement that makes sports illustration so challenging. Let's look at this one closely and identify the drawing issues.

1. This pose is full of angles. Look at the tilt of the shoulders, for example. Do not draw them straight across or the movement of the pose will be lost.

2. This pose is also an example of foreshortening. Look at the leg coming forward. The length of the upper leg is shortened as well as the length of the foot. Also, what little shows of the bat is clearly a foreshortened view.

3. The lighting of this picture creates strong contrast. Look at the extremes between light and dark. These differences in value make artwork exciting.

4. The uniform is a good example of interrupted pattern. Notice how the stripes follow the contours of the body, as well as the creases and folds. The shadows were blended first, then the pattern was applied.

5. This pose also shows a lot of movement. The twisting motion of the torso shows the figure is in the middle of an action situation.

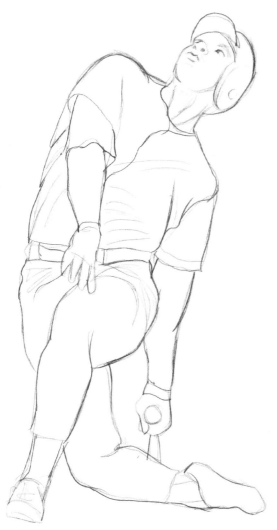

This line drawing shows the fluid movement of the figure. The twisting motion of the upper body shows action. Look for the effects of foreshortening in the leg on the right.

Always remember the many angles when drawing. This pose has a lot of angles due to the stress of the fabric combined with the unusual position of the body.

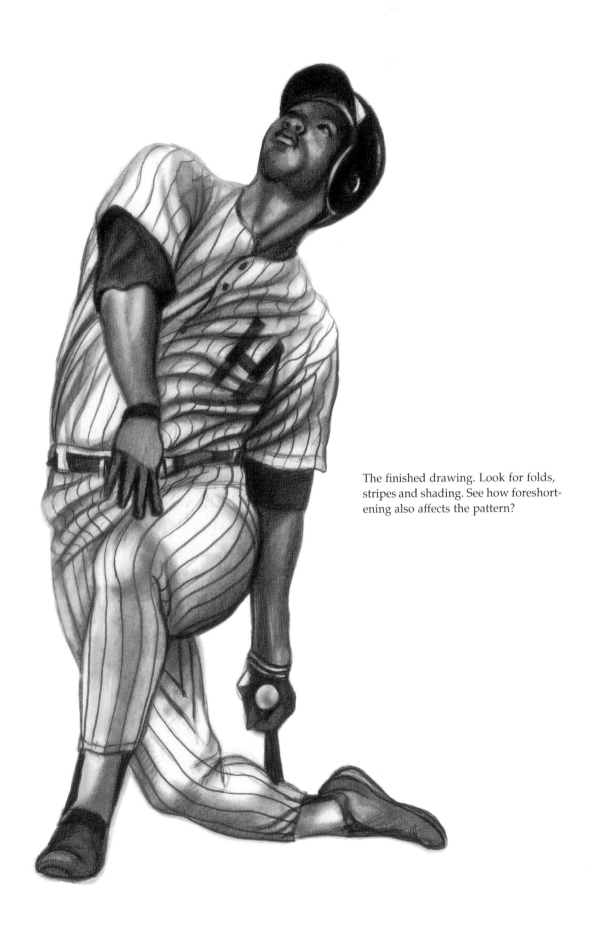

The finished drawing. Look for folds, stripes and shading. See how foreshortening also affects the pattern?

SPECIAL EFFECTS

Now that we have learned some of the basics regarding sports illustration, it is time to take it to a higher level. This involves adding creative elements that will make your artwork more interesting and visually attractive.

Special effects can be bold or enhance your work in simple, subtle ways. Whichever you choose, they should never take away from the main subject, or focus, of the illustration.

Here I've enhanced the contrasts to make the figure more dramatic. By making the dark areas much darker than in the reference, the light areas seem more intense. The light source is clearly evident.

Notice the shadow falling along the left side of the body, and how the tilt and angle of this figure create a true sense of movement and action. These are the qualities that make sports illustration more graphic than other types of drawing.

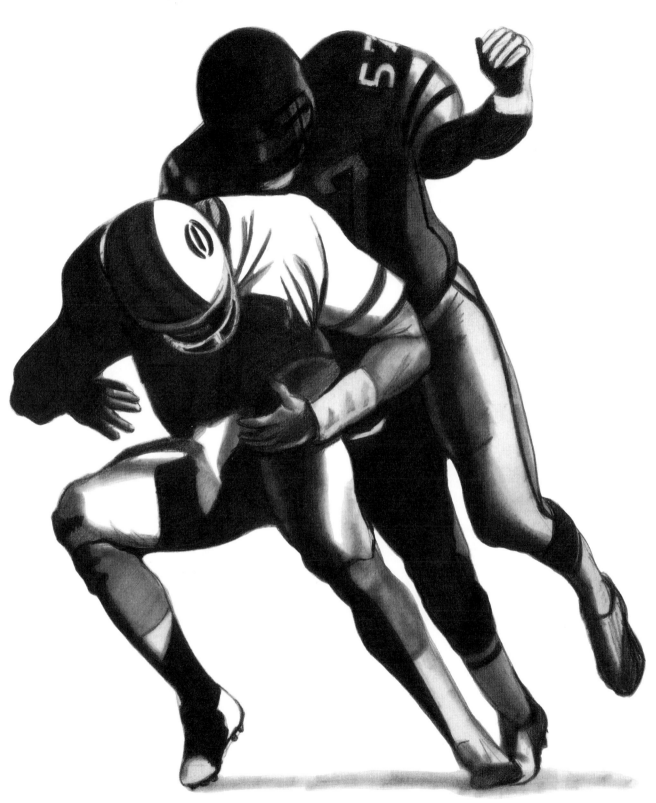

I used this enhanced contrast technique with this drawing also. The combination of the overlapping subjects creates contrasts of even greater intensity. The strong contrast of black against white looks more like a design pattern, as opposed to a realistic rendering.

ESTABLISH YOUR LIGHT SOURCE

As you saw in the previous illustrations, shadows and contrast are essential. This drawing is more realistic in its appearance but the use of shadow makes it a more interesting piece. See the shadow shape of the fingers on the forearm and the shadow of the arm against the bicep, and across the face. All of this creates the light source.

Look for all the elements we've studied so far.

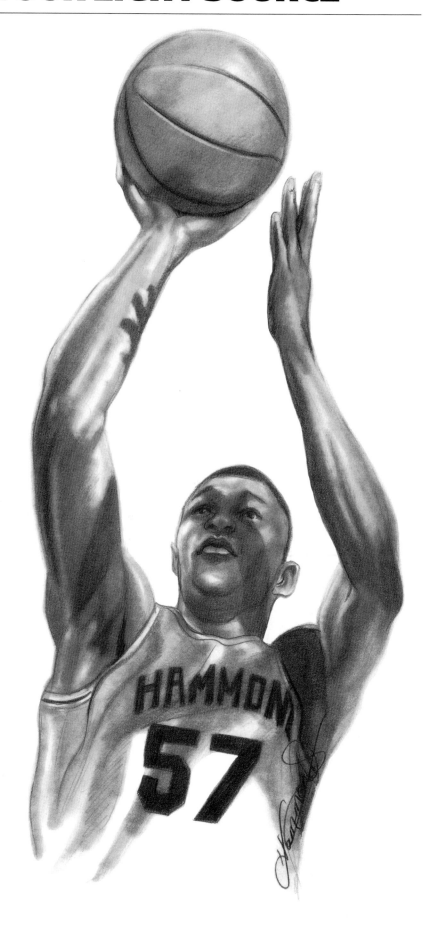

Look for the use of shadows on the arm and across the face. Other things to look for are the five elements of shading; shadow edges and reflected light; the use of shadows and contrasts to create the light source; and the feeling of form and movement in the clothing.

ADD VISUAL IMPACT

There are fun things you can do to your artwork to give it added visual impact. I chose to add some line and tone to these pieces to increase the feeling of movement and action.

Whatever you do, make sure the figures are still the focal point. The background special effects should do nothing but lead the viewer's eyes to the main subject.

The drawings here have all been drawn with a loose, sketchy approach. It gives them a more graphic, rugged look. Try various drawing techniques as you explore sports illustration. Each new technique will lend a different look and feel to your drawings.

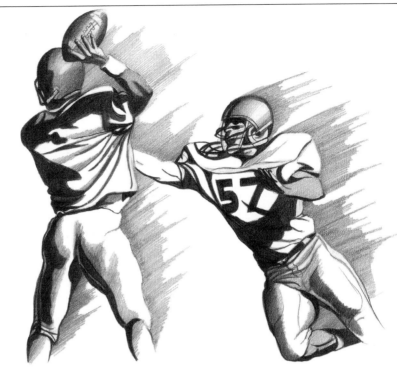

Note: Take some of the illustrations we've done so far and add backgrounds like this to them. See how much you can change the look and feel of the drawing.

Here is another example of extreme contrasts. I deliberately intensified the lights and darks to give it a graphic look. The action tone behind the players gives the figures movement. It almost looks like they are traveling through the air.

The intense background of this drawing enhances the action. It gives it drama and movement. The dark tones combine with the serious expression of the ballplayer, making this a serious illustration with a lot of feeling.

I finished this drawing in the line stage. It gives the illustration a light, airy look. The figure appears light on his feet and suspended in midair.

COMBINE TECHNIQUES

Unlike the drawings on the previous page, these illustrations use the blended pencil technique. It gives them a more realistic, as opposed to graphic, look.

As you can see, many techniques can be used depending on the look you are trying to achieve. Think your project through before you begin to draw. Study your photo reference, decide on the look you want, the feeling you're trying to describe. The possibilities are endless. In the following illustrations I will show you more ideas for dressing up your artwork.

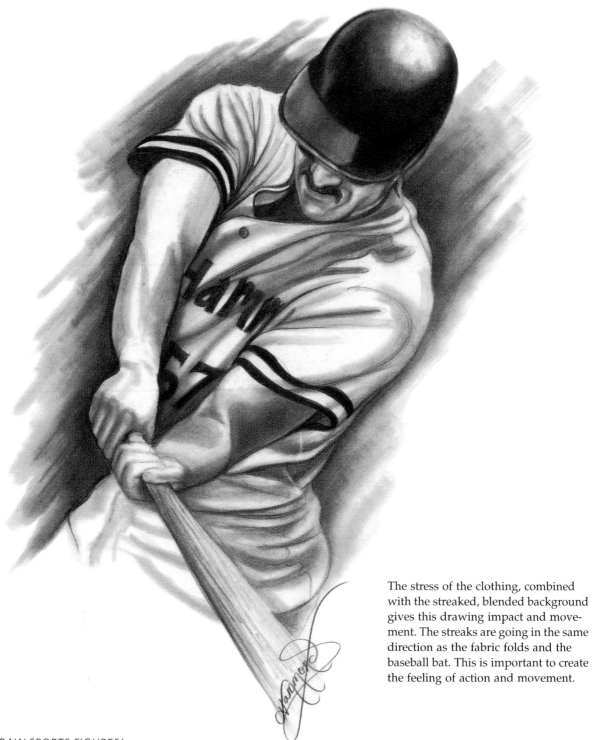

The stress of the clothing, combined with the streaked, blended background gives this drawing impact and movement. The streaks are going in the same direction as the fabric folds and the baseball bat. This is important to create the feeling of action and movement.

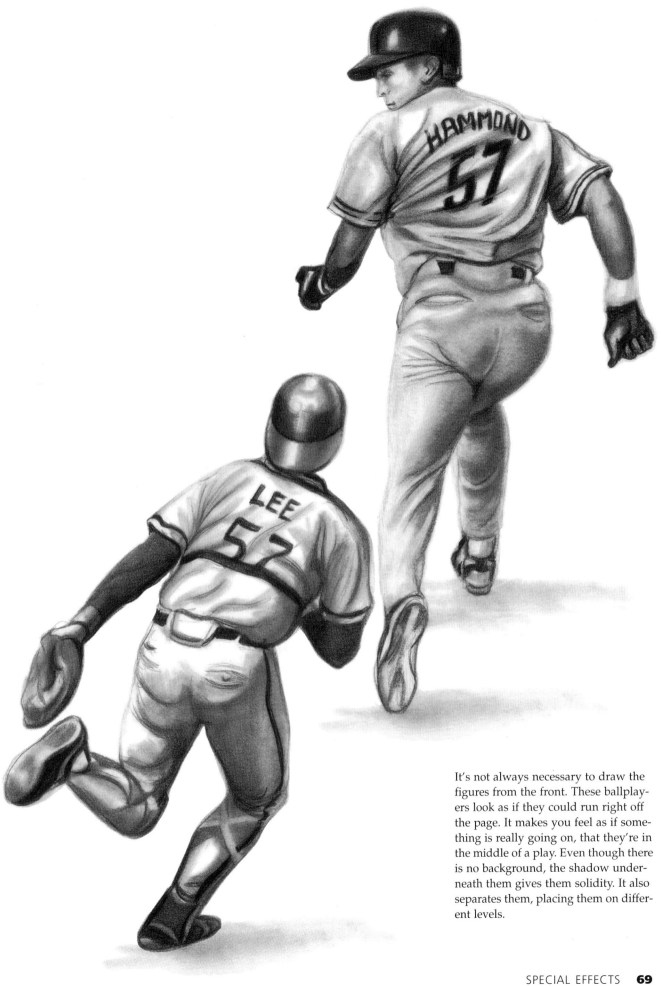

It's not always necessary to draw the figures from the front. These ballplayers look as if they could run right off the page. It makes you feel as if something is really going on, that they're in the middle of a play. Even though there is no background, the shadow underneath them gives them solidity. It also separates them, placing them on different levels.

BACKGROUNDS

Each of these drawings uses a different background treatment to enhance the feeling of distance or movement. It's all illusion, designed to make the artwork more expressive and meaningful in its storytelling ability.

Whether realistic or graphic, the background is an important tool for creating meaningful and memorable artwork.

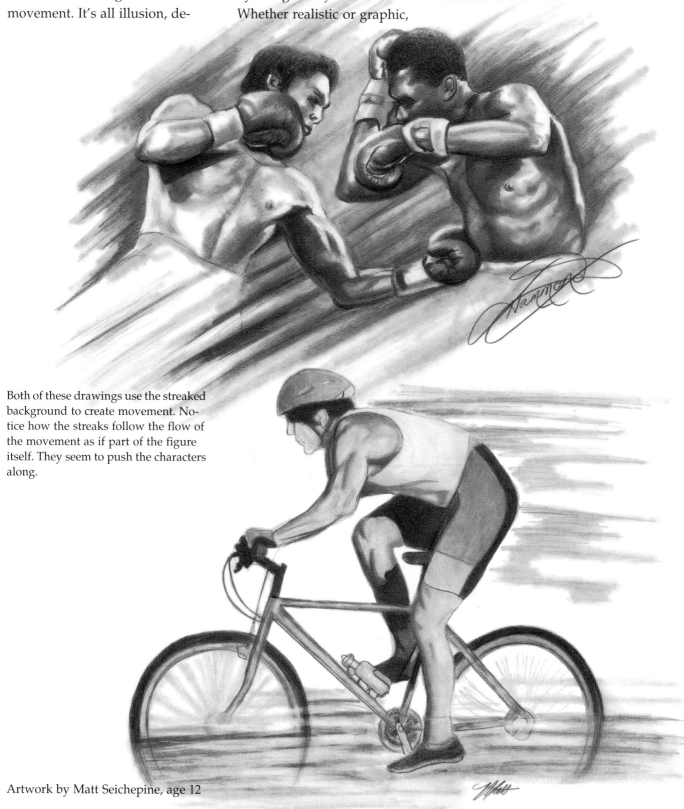

Both of these drawings use the streaked background to create movement. Notice how the streaks follow the flow of the movement as if part of the figure itself. They seem to push the characters along.

Artwork by Matt Seichepine, age 12

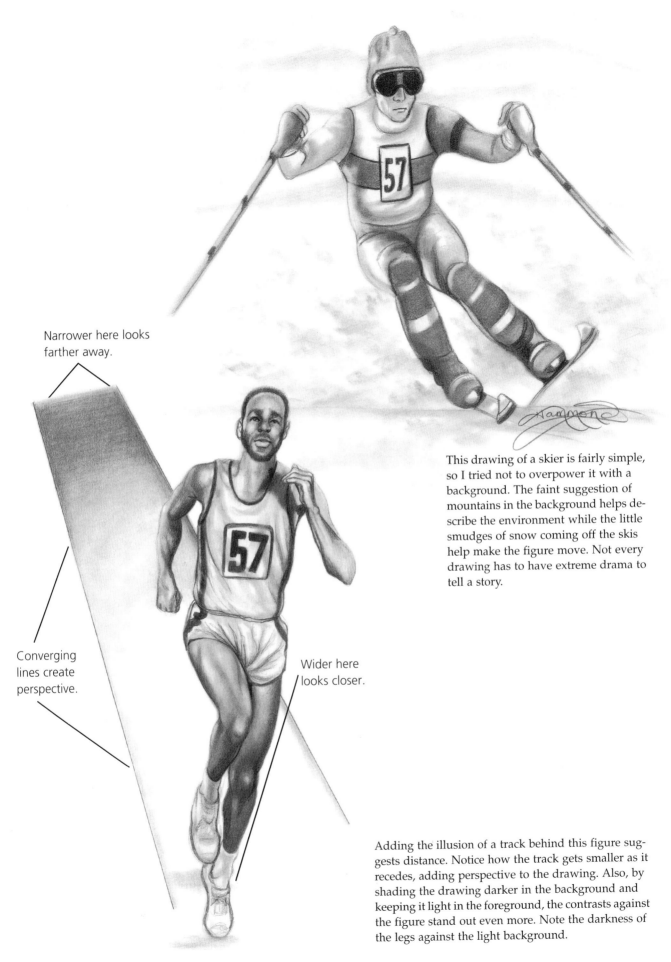

Narrower here looks
farther away.

Converging
lines create
perspective.

Wider here
looks closer.

This drawing of a skier is fairly simple,
so I tried not to overpower it with a
background. The faint suggestion of
mountains in the background helps de-
scribe the environment while the little
smudges of snow coming off the skis
help make the figure move. Not every
drawing has to have extreme drama to
tell a story.

Adding the illusion of a track behind this figure sug-
gests distance. Notice how the track gets smaller as it
recedes, adding perspective to the drawing. Also, by
shading the drawing darker in the background and
keeping it light in the foreground, the contrasts against
the figure stand out even more. Note the darkness of
the legs against the light background.

BORDERS

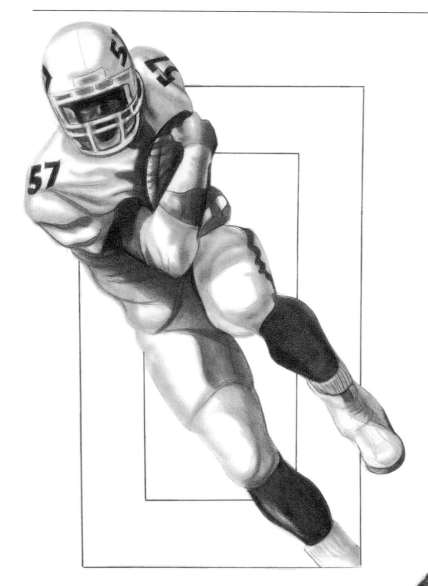

Another type of graphic look is the border box. It is nothing more than a rectangular box drawn behind the subject to make it stand out.

What makes the border box so effective is the way it frames the figure. By allowing the subject to come out of the border you give it distance.

Look at the way the figures break through their borders, adding interest, in these two drawings.

By using a double border here, the football player looks as if he's coming out of a tunnel. He seems to project into the foreground. Keeping his feet inside the border makes it look as if he is breaking out.

This border box also cuts into the figure; the horse seems to be jumping out of its confines.

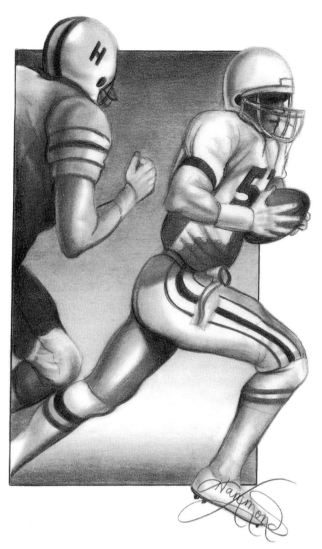

This border box contains both football players. The darker background shading gives the impression of distance. Taking the player out of the border creates movement—the impression that he will escape the other player. Being lighter than the other figure, he becomes the focal point.

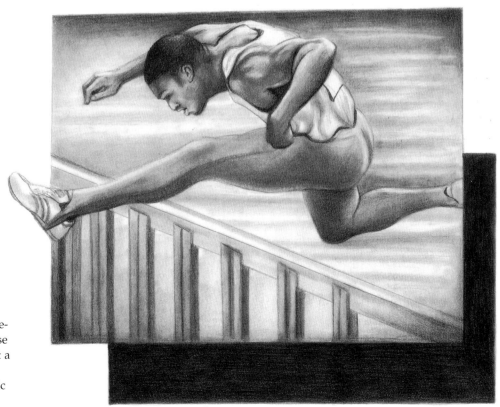

I used a combination of elements in this piece. The use of a double border gives it a graphic look. It contrasts sharply against the realistic drawing above it.

USE YOUR IMAGINATION

Special effects can be simple or complex. What makes them most interesting is the amount of imagination you apply to them. Here are three examples I find unusual and fun to do.

This is a different spin on the border-box theory, but this time the boxes have been turned into unusual shapes. I used the circle behind the basketball player to repeat the shape of the basketball, shading around it for added drama. You could take it a step further and make the circle a moon to be really creative.

The diamond shape in the next drawing portrays the baseball theme. Note how the points of the diamond lead the viewer's eyes right to the figure. You must choose your background carefully. Composition is important.

I like how this geometric border contrasts the high degree of realism in the rendering of the football player. The most interesting part, I think, is the shadow of the arm cast down the side onto the leg. Can you see the shadow shape of the hand? Look at the fabric creases of the shirt under the shadow. It's this type of detail that makes a drawing more than just a sketch, turning it into art.

Let's take a look at the background. The darkened corners create a framework that leads the eye into the picture plane to focus on the main subject. Using a heavily shaded, mottled background gives an illusion of distance.

There are two ways to draw a composition like this. First would be to draw the shape you want on your paper, then place your subject in it. I used the second way: folding my photo reference into an unusual shape and then drawing from that. Either way it's a great project.

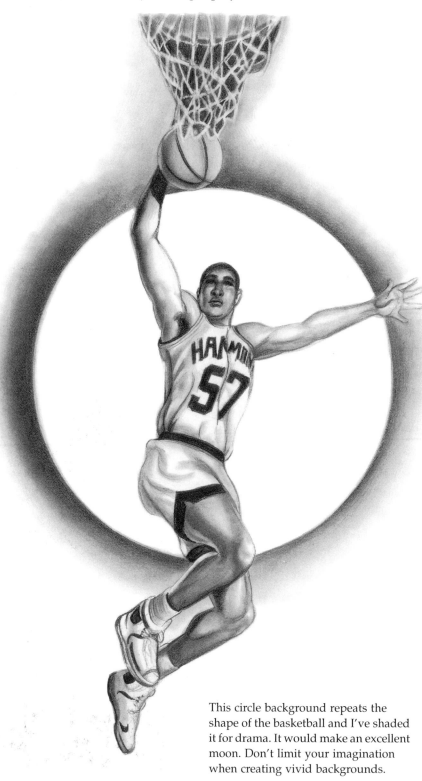

This circle background repeats the shape of the basketball and I've shaded it for drama. It would make an excellent moon. Don't limit your imagination when creating vivid backgrounds.

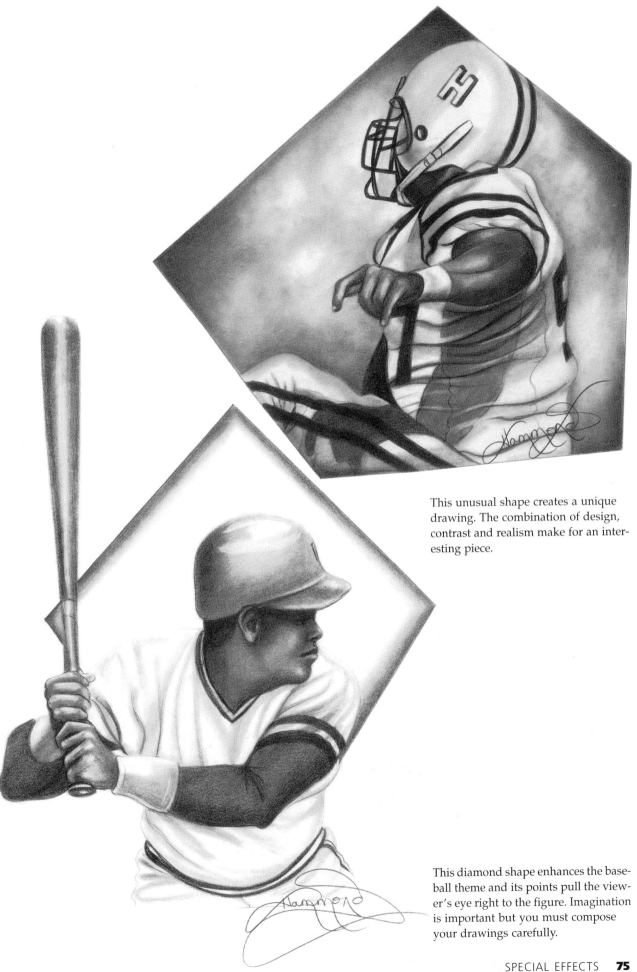

This unusual shape creates a unique drawing. The combination of design, contrast and realism make for an interesting piece.

This diamond shape enhances the baseball theme and its points pull the viewer's eye right to the figure. Imagination is important but you must compose your drawings carefully.

SUGGEST THE CROWD

Backgrounds can be an integral part of your drawing. They can help you tell a story with your art, but the background should never take priority or pull focus from the main subject. It should be a support element, not a distraction.

Both of these drawings use background to depict the feeling of a crowd or audience. However, both of the backgrounds have been blended out, making them appear subtle.

I used the border box in this illustration to contain the subjects. With so much movement, and this many figures, it would have been easy for this drawing to lead your eye all over the page. The box frames it, keeping your eyes in the center.

This drawing uses the background as the suggestion of a crowd. Notice the faintly applied shapes resembling people. They're just enough to give the impression of the sidelines at the game.

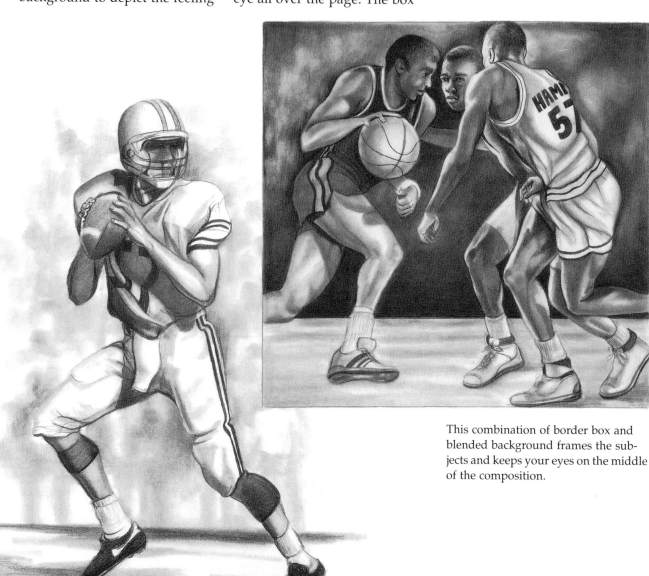

This combination of border box and blended background frames the subjects and keeps your eyes on the middle of the composition.

◄ The faint application of figures in the background helps illustrate the feeling of the sidelines. And the background's darkness makes the light edges of the subjects stand out.

MONTAGE

This is a montage, a grouping of many subjects in one composition. It combines abstract, geometric shapes with finely detailed renderings of realism. The outcome is a fun, interesting piece; one that makes you take your time while looking at it.

I drew this for my son, because of his love of basketball. First I created a geometric composition of shapes. This step takes a while to compose. You must have good balance between the large and small shapes or one side of your drawing will be visually heavier than the other.

When I was happy with the look of the whole composition, I selected photo references that would fit the geometric shapes. This also takes time. For instance, it was not easy finding a grouping that would fit into the unusual shape on the bottom. I had to be careful not to put too many basketballs close together or black and white shapes side by side. I like the way the edges of each shape cut off the drawing, creating a mini-composition within each shape and design.

Here's a method to help you find the right subject for each shape: Draw out your entire geometric composition on an 8½" × 11" piece of paper. Make as many copies as there are shapes (plus a few extras—my drawing has sixteen shapes, so I had twenty copies made).

I took one copy at a time and cut out one of the shapes with a craft knife. Next I looked at photo references through the cutout until I found one that looked right within that shape. I then drew it into the corresponding shape on my drawing paper. I drew it in black colored pencil, rather than graphite, for more intensity.

Although this looks like a complex undertaking, it's nice because you can concentrate on one shape at a time, finishing one portion before moving on to the next.

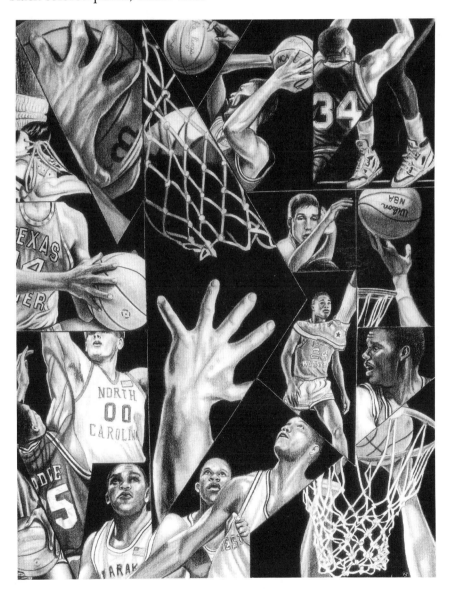

This montage combines abstraction and realism. Each shape contains its own mini-composition. This grouping had to be carefully thought out and balanced according to shape, tone and subject matter.

CONCLUSION

There is no limit to the amount of amazing artwork that can be created from the world of sports. There are so many types of athletes and sports that I was not able to cover in this book—there probably isn't a book large enough to display them all. Our possibilities as artists are unlimited.

I encourage you, now, to try as many types of sports artwork as possible. Let your creative abilities run as wild and free as the athletes in this book. Push yourself to the limit. Think of yourself as an artistic athlete, and train yourself daily for your event. The harder you push yourself and the more you practice, the better you will become.

I like to include some of my students' work in my books. It helps the reader to understand what can be done by following these techniques and my guidelines.

This beautiful drawing is by one of my younger students. It was taken from a vacation snapshot. The use of shadow, contrast and background give this drawing a lot of visual appeal. Look at the depth and distance he has created.

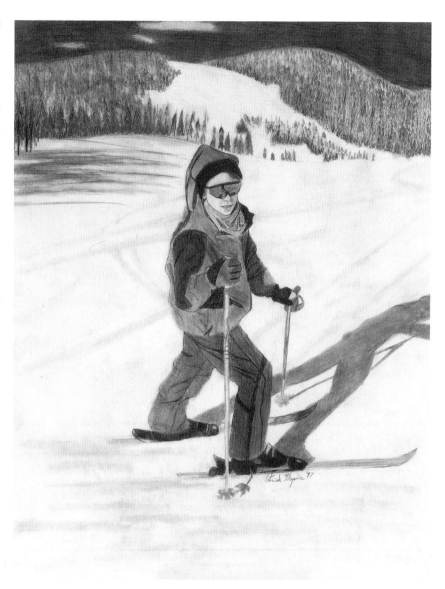

Shadows, contrast and background create a realistic rendering of a ski vacation. The sense of depth and distance is beautiful.

Artwork by Patrick Maguire, age 12

As always, my heartfelt wishes for success are with you. I remember when my art career was first taking off; it was both a joyous and frustrating feeling. Trust me, it doesn't change, for we never know it all. We continue to grow, to learn and to experiment. Don't give up when you encounter problems. Just keep trying and you will figure them out. I had no one to show me the way and I did it. So can you. I believe in you!

Best wishes,
Lee Hammond

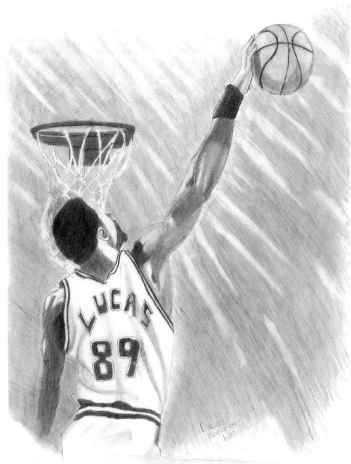

Artwork by Lucas Slater, age 8

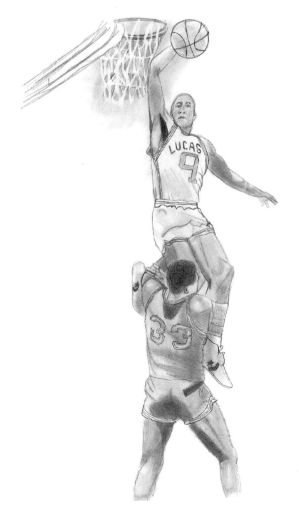

INDEX